NICHE

NICHE

A Novel
by
Séguier and Plessis

with
Brief Manifesto of
Le Laboratoire
by Séguier

and
Photos by D. Faust

Editions Le Laboratoire

Brief Manifesto

A niche is a place of belonging, of history, of soul. It may be a hallowed place, like that specially crafted corner where you display some beloved sculpture, or it may possess only passing interest – a secluded café in a strange city you visit for a week and never see again. Certain niches, whether hallowed or of mere passing interest, can transform you in ways you do not immediately understand, and may never control, as if a horde of ghosts were to catch your attention, and solicit your response, wishing you to discover what they saw here first.

Rue du Bouloi in central Paris – the setting for our curious story – is a niche in this latter sense. Located about 200 meters north of the Louvre, and 200 meters east of the Palais Royal, it is approximately 200 meters long running northeast from 10 rue Croix des Petits Champs to 27 rue Coquillière. Here the Farmers General had their offices from 1690 until the debut of the French Revolution, and, in the early 19th century, the public carriages of Vincent & Caillard transported Parisians to distant places like Belgium, Holland, and England by way of Calais from the *cour des Fermes*. The printer Paul Dupont established on rue du Bouloi one of France's most important printing presses around the time of the 1889 Paris Exposition – a thriving business that continued long into the next century.

On rue du Bouloi you will happen upon specters everywhere. Moving by, you might even sense a slight pressure on your skin, a feeling like feathers brushing your cheeks, though should you reach out a hand, the throng will inevitably disappear.

On rue du Bouloi buildings have risen and fallen, fortunes come and gone. In 1359 we called it rue aux Bouliers, a century later, rue de Baizile, a century after that rue de Buliers, and, finally, when the Chancellor Séguier purchased the entire street in 1634, rue du Bouloi, probably the name of an ancient game of boules.

Armand Jean du Plessis, known better as Cardinal Richelieu, appeared to the world at 4 rue du Bouloi on 9 September 1585. In his rich and checkered life he transformed French History, centralizing the Hexagon, among other things. Thanks to the Cardinal, France flourished for a long while, notably innovating in art and science, from Molière and Descartes, to Voltaire and Laplace, to Cézanne and Pasteur.

As latest arrivals to the du Plessis family plot of land, the birthplace of the founder of the Académie Française, we at Le Laboratoire, ever mindful of the Bouloi specters, are particularly sensitive to this legacy of art and science.

Since Armand's day art and science have changed the world, more, we believe, than any nation has or can. Progressively they have created the possibility of moving power from nations to individuals. Armand shaped his world through international diplomacy, while we hope to re-shape ours through individual creativity.

We aim to catalyze this creativity through the innovation potential to be found in the reflection that takes place between the intuitive and the analytical, the undefined and the defined, the image and the equation. We explore this potential through annual experiments involving creative process that is neither purely conventional art nor purely conventional science, but something in between.

We call this artscience.

What emerges from artscience experiments assumes at Le Laboratoire the form of art and design – even if we pay more attention to the fun, the surprise, the learning.

Most labs conduct collaborative experiments, and that is the case with us as well. Like the Cardinal, we collaborate in everything we do. At Le Laboratoire we bring together leading international artists and leading international scientists to perform experiments that have never been done before.

We hope the result will interest the public, although it would not be a true experiment if we knew surely that it would. About creative process we are more certain, and, since creative process is less commonly highlighted in a catalogue of the kind we hoped for to inaugurate the opening of Le Laboratoire, we have decided to invent a new genre.

We call it a novel catalogue. In the novel catalogue the process through which creators create matters as much as the works that result from their creation. This clearly distinguishes it from the conventional catalogue.

The novel catalogue fictionalizes a strange but true drama (all the more true for being fiction) that accounts for the works of art and design you will witness should you enter Le Laboratoire sometime during the season in question, in this case the 2007/8 Season, our first.

What would you see?

Matière à penser is a major contemporary art installation resulting from a collaborative experiment between the plastic artist Fabrice Hyber

and the MIT scientist Robert Langer. The exhibition captures an instant in the creative artscience process alluded to in *Niche* through the dreamed-up story of Santiago and Robert. In Hyber's exhibit, the proliferation of objects, of models, of videos and paintings recreate the studio of the artist as if it were a photograph of his thought. Bel-Air is a novel design exhibition resulting from a collaborative experiment between the designer Mathieu Lehanneur and the Harvard University scientist David Edwards. Drawing on experimental observations of NASA scientists, Mathieu Lehanneur and David Edwards have created a new form of air filter that passes dirty air past absorptive surfaces of plants, thereby improving the capacity of plants to absorb noxious gases and particles, and, in a sense, render plants "more intelligent."

Niche is then populated with shadows of the artists and scientists who brought our experimental institution into existence and made our first public exhibition season. The artist D. Faust captures photographically some of the true moments, places, and discoveries encountered along the way. This combination of words and images gives us something of a coming-of-age story.

It is also a lesson in cell biology.

I tell this tale from my own admittedly spotty recollection – with the collaboration of my friend the novelist Plessis. He is more decidedly the artist, I the scientist. True, I often enter his world and sometimes invite him to explore mine; after all we would not get along if we did not see the other's reality, even share it occasionally. But, mostly, I stand on one side of the artscience fence and he on the other. Everything we create at Le Laboratoire happens collaboratively across this proverbial fence – so this does too.

Our characters are of exquisitely selected and screened nationalities and ethnic origins: British German American French-Indian French-American French. Everyone is younger than a mid-forty number except for Plessis, who is just over the limit, but remains lighthearted about it.

In my story the events and emotions of the past years are told without perfect regard to chronological faithfulness. I am confident you will however figure it all out and successfully connect our tale of love, death, and cellular division to what you will see if you happen to visit Le Laboratoire sometime this year.

Séguier
Paris
July 2007

Anderson, a hulking, broad shouldered, blond Californian, slouches down in a cold vinyl seat in an empty fish restaurant just behind MIT wondering, in a rather wonderful way, if an artist can know *better than a scientist* how a stem cell produces a neuron, as David says one can. All morning our meticulous cell engineer has posed and re-posed his question even as he threw slide after busy scientific slide up on the white wall of the cramped prison of a conference room not far from Robert's office.

The artists – and there were thirty two of them – showed brief sparks of interest. Anderson admits they did. For instance, a few of them actually nodded when Anderson talked about the embryonic as opposed to the adult stem cell; one asked Anderson to replay *three times* his film of cell division; and all thirty two appeared to appreciate his polymer scaffolds.

And it was then, just after Anderson showed his picture of the poly lactic co-glycolic acid scaffold, that the small brunette, the one with the fierce look, noted how finally alike we were, stems cells and us, how already human the thing we are formed from is, stems cells aiming to become something that they are not, eating and reacting and changing …

What was that about?

She sits next to him now in this empty Cambridge restaurant, the little fierce-eyed artist, and across the table from David, who announced to Anderson this morning that one of these artists was going to create an artistic innovation based on Anderson's little lecture on stem cells.

Is it her?

Big Anderson leans her way, not completely sure whether she is going to understand.

"What is it?" the brunette prods.

"The work of art," says Anderson. "What is it going to be? A painting? A sculpture?"

"Maybe a dream."

Anderson laughs nervously.

David and Caroline laugh, too. It is a first new idea after a long morning (Anderson is smart as a whip but what did he create today?) and it relieves them both.

Something may come of this, after all.

Eight years back in time. David stands in an apartment overlooking the Carrefour de l'Odéon. He wades through the sunlight that pours over the old parquet floor and across his black shoes and jeans. He loves the feel of this place but has no clue how to evaluate the merits of such a thing. Only a year ago he was in debt and dreaming with no clear plan as to how he would realize even one of his dreams, not sure he ever wanted to, and, then, an idea he had sold at a premium, sold as ideas did in the late 1990s in Cambridge America, and he had instant money. This pretty much explains the disoriented state he is in now, April of 1999. He cannot say what comes next. The future is a blur; the present for that matter, too.

"It's okay," says François the Architect. Debonair François stands in a corner with his colleague Christian, the one with a big torso, peering over François' shoulder. The apartment is worth fixing up, apparently. It will be a nice place when François and Christian are done with it.

With time David learns to trust François. They meet for lunch or dinner whenever David is back in Paris. And, then, one day around 2002, they set off on a quest for something special – a place for friends and exploration and creation.

David wants to be free of Fortress America. What has happened to his country? He feels too near to answer. And since to be free is to create he must find a place for creation – outside of America. He does not know what this means other than that the creation will matter to others than just David and friends and will take place in the center of Paris and feel big and raw; and light will do in it special things.

David and François scour the 1st 2nd 3rd 4th 5th and 6th arrondissements searching for empty warehouses and parking garages. They study the merits of a magical space in the Marais and a mythic theater not far from Edward VII, but nothing feels quite right.

Then, one morning, after a few years of this, François calls David in the USA. There is a place he must see next to the Louvre, a place with ghosts who can help in the magic to come. Their common friend Philippe has found it. David must come – soon. He has maybe three weeks. After then it will be gone.

David travels to Paris. He buys 4 rue du Bouloi with all its ghosts. He meanwhile obtains a French passport. Like a stem cell, he is transforming.

a **cell** eats and drinks and burns up energy like we do. you might think of it as life's smallest complete unit of structure and function. true, molecules and atoms and subatomic particles are all smaller and obviously necessary – but their talents are vastly more limited. cells gather information in genes. a layer of fat encloses them and gives them their shape.

a **cellular engineer** manipulates cell structure and function out of curiosity and, in most cases, medical altruism. the goal of our cellular engineer may be to build a new liver or repair cartilage – though most time is spent working with materials that mimic biological tissues – and that we call biomaterials.

It is cold tonight. David and Caroline have walked through a quaint city garden and around a lovely iced pond to the Bristol Lounge. David's friend, Cantor, a Woody Allen look-alike (Caroline said that tonight), is happy here on his sofa next to a chimney with its electric roaring fire and a bottle of David's favorite Chardonnay split three ways. He drinks from his glass while watching David.

"Intelligence?" Cantor muses softly, a little miffed that he should resemble Allen and not the reverse, which leads him to wonder, as he does anymore after a glass or two of wine, at the irreversibility of time, at the asymmetry of fame. And vice versa, of course.

"That's the theme," says Caroline, making Cantor turn to her. She is with him on the sofa wearing a black scarf with large orange balls on the ends, artful and poetic, like Caroline.

Cantor wants to know why. The exclamation he gets; but why intelligence? David says that the first year theme at Le Laboratoire reflects less what he knows than what he wants to know because apparently nobody knows what intelligence actually is and David hoped to explore it with friends like Caroline and Cantor.

It's a party. They are drinking too much.

Cantor: "I could while away the hours … Conferrin' with the flowers …"

Caroline: "What's that?"

David: "The Wizard of Oz. The scarecrow. The scarecrow's song."

Cantor: "Yip Hapburg wrote it." Cantor is perhaps more priggish than Woody Allen. "Music by Harold Arlen. That could be our song. I mean on the search for intelligence."

Cantor sings:

> I could while away the hours
> Conferrin' with the flowers
> Consultin' with the rain
> And my head, I'd be scratchin'
> While my thoughts were busy hatchin'
> If only I had a brain

Caroline applauds – "Bravo!" – Cantor's surprise performance while David, who dreamed up this crazy competition of French artists, sips his glass of Chardonnay.

He wonders how it would be if a stem cell happened to sing. Would anyone hear? Would it sing better than Cantor had?

Earlier today, after another lab visit with his thirty two artists, this time with the Harvard scientist Mooney at Harvard, he heard it said that

intelligence, a grand theme, remains a troublingly ambiguous word. we might mean by it some logic, recognition, assessment, decision-making and memory skill property. but which? there are assorted measures. a very famous one is the stanford-binet iq measure, developed by french psychologist alfred binet in the late 19ᵗʰ century, and modified many times since, achieving its most popular form through the 1916 work of stanford university psychologist lewis terman. many dispute this as a measure of intelligence. the harvard professor howard gardner, for instance, argues that people possess multiple intelligences, and proper measures of intelligence should account for these. whatever the measure, intelligence seems to depend on brain mass, genetic and ethnicity factors, and environment, including nutrition – related to socio-economic status and lifespan. some see in intelligence a correlate with education and professional success, while others see it as a social construct, which stephen jay gould famously associated with scientific racism. intelligence can also be engineered into inanimate materials ranging from robots, to chess-playing machines, to environmentally-responsive materials, to medical devices. there seems no unambiguous established way of – measuring the intelligence of these things.

there was only one way to know what intelligence is, to learn deeply each lesson Robert and his colleagues gave, and that was to become something they were not, to become intelligence itself, for intelligence, like stupidity, must be in the being – or, in the becoming, for in David's experience there is no difference.

The magical artist who will open Le Laboratoire will become a stem cell and from there a neuron. David does not need to hear a stem cell sing. The Artist shall sing. The Artist will be a stem cell-becoming-a-neuron! The Artist shall, on his own, and through the magical art force, become an embryonic stem cell scraped off some available baby embryo blastocyte and figure out on his own the path to transformation through cellular division. Such is the Yellow Brick Road. The artist will wile away the hours.

He will grow a brain.

16

Mathieu leans over the white Formica table top gamely awaiting the professor's next words. The latter has round shoulders, a bald crown, and frumpy professorial clothes – white shirt with two pens in the pocket and blue polyester pants. Scientist bores designer, leading designer to worry about this idea of David's to sit with a man he has never met, never even heard of, to talk, of all things, about intelligence. This scientist presumably has it. But to what end? Does intelligence have to possess an intelligent use, an intelligent purpose? Then something would have to be the intelligence of intelligence. And so on …

"I don't work on brain problems anymore," says the frumpy man with some aggression in his voice. "I used to. Sort of. I studied the blood-brain barrier. Drugs getting across. That kind of thing I did, but I don't do it anymore." He stares blandly at David. "Is that why you came to see me?"

"Then just tell us what you do," David hits back, holding on, Mathieu thinks. He will not give up. First of all, he doesn't like to let a friend down. Second, he knows that discovery sometimes requires directness, even rudeness, kicking up stones, or shaking up mixtures. And sometimes one does have to be the intelligence of intelligence. The director of the Lab. David told Mathieu that a conversation at the University of Paris would inspire Mathieu to design something that had to do with intelligence and he is not about to let this fellow here prove him wrong. Mathieu sighs; were David not so stubborn about it they might all return to the

the **stem cell**, our book's hero, is common to all multi-cellular forms of life. it renews itself through cell division, and - with proper signals from the environment (electric shocks, tasty meals, fortified liquids) - differentiates through cell division into cells ranging from blood cells to neurons. embryonic stem cells are, as the name implies, found within young embryos – we call them blastocytes – and can differentiate into all the specialized cells of the human body. by contrast, adult stem cells have very limited cell production powers.

Luxembourg Garden and breathe fresh air again. "We're here," David goes on, expressing the thought that is on everybody's mind as he paces comically next to a wall decorated with the scientist's awards, "I'm sure we'll find the context in just a moment. About what you do now" – he stops and faces the professor, who suddenly leans back in his plush swivel seat next to a Dell computer – "I'd like to pursue that a minute."

"What do you want to know?"

"You work on delivery systems."

"Polymer micelles."

"Nanoparticles."

"Right."

"Gene delivery."

"DNA."

"There it is!" David stares hopefully at Mathieu. He has his hands in the air, palms facing the fluorescent lights on the ceiling. "You see?"

No, frankly, Mathieu does not. He smiles faintly with lips pressed tight. He looks over at Olivier, who avoids eye contact, and then past the bald head, and out the window.

Green leaves flutter in the early autumn wind. Mathieu dreams of another kind of intelligence. It is an inhuman kind, an intelligence that transcends humanity, or perhaps binds humanity to nature, humbles it by showing mankind that it is not so special, not so smart, and that it can learn by observing nature as much if not more than by fooling around with nature through whatever it thinks to understand of DNA and all that. Of course, before one intervenes, one must study. But if Mathieu had his way, there would be much more study, much less intervention.

Over these last couple years Mathieu has taken an interest in plants. This fancy follows a phase of interest in medical devices, where he looked into the beauty, the art, of healing, hoping to render things scientists made to cure people more friendly to the people it aimed to cure. Nothing special came of it.

So he turned to plants. Plants eat drink sleep – in a way – grow age die. They love us and we do not love them. They save our lives and we kill theirs. They are smart and we are not.

He made a few designs for plants and did well with them.

A green leaf, he muses. The secret to intelligence, Mathieu believes, lies outside the window fluttering in the wind.

But what is intelligence? It is an act, a gesture, the delivery of an effect that promotes life. For Mathieu intelligence is in the doing.

That is why he will create his design around the intelligence of a

leaf. He will do it to spite the frumpy one who presently gathers David Olivier Mathieu around his Dell computer screen to watch a computer slide show that will reveal to them something – he seems uncertain and unconcerned what – that will justify the time he invested to make it.

Later they walk to a Japanese restaurant on the Boulevard Saint-Michel and have a surprisingly agreeable lunch and the conversation turns out to teach Mathieu things that will be useful to him with his plants and he does not regret this day with David after all.

Olivier leaves lunch early. He must return to Italy. Why Italy? Mathieu will learn some other time.

Robert despises thermodynamics. He really does. It is not that he cannot learn the theorems or memorize the corollaries. It is not that he cannot see to associate energy with production and entropy with disorder and generally connect the endpoint of thermodynamics with the start of something useful. He sees the reason and beauty and utility of thermodynamics. But reason beauty utility all take different forms in Robert's brain. And a few years ago the cover of Boston Magazine labeled him the Smartest Man in Boston.

So there must be something to it.

Robert is not a scientist like many others. And, as he has come to know a few artists in his life, a few Hollywood celebrities through the circles of fame he occasionally crosses into, he sees at once that these artists (how did David choose them?) are not artists like many others, either. But to call him the smartest man in Paris? That would, as they say in mob movies, make him a marked man.

"Want another glass?" He points the bottle toward the little brunette. Will it be her? Is this the artist with whom he will create? Perhaps it will be another, another clever artist.

Robert doesn't need to know. He is simply happy to have all these artists at his home. He will invent with a French artist! The idea somehow reassures him. He has no doubt they will discover something wonderful. Why? Robert discovers something every day of his life. It is the easiest thing for him. There is an artist here who is like him, he senses. Why? It might be confidence in David. It might be that he does not care if it isn't true. Anyway, they will invent.

And what will their invention be? That he cannot say pleases Robert deeply. He has invented too long not to place a premium on

a **nanoparticle** (imagine a mite, only billions of times smaller) is usually larger than a few nanometers and smaller than a few hundred nanometers. scientists are not always clear about what they mean by the word – although it certainly refers to a particle that is very small. because of its size it mostly escapes the force of gravity (even the tiny force of gravity that overwhelms the effect of gravity for such little objects). this means that it moves in space unlike other particles do. you might envision it as a drunk dancer moving aimlessly around a dance floor late into the night. it also has the capacity to cross cell membranes, which is very useful since "nanoparticles" of natural biological material constitute much of the information highway of life. since nanoparticles have these unusual properties scientists often use them to design systems to engineer cells and cellular organisms.

a **leaf** does many wonderfully smart things. in a way it is like the tongue of a dog. it absorbs gases and moisture from the atmosphere and passes useful nutrients to the plant or tree. some plants absorb certain gases better than others do. their intelligence, as we have thought of it, comes about in that they know to take from the air chemicals that can be useful to the plant – and harmful to us.

novelty. Boredom – the expected – is for him the enemy.

"Pierre-Yves," Caroline cuts in with a laugh across the table. She studies the grey haired artist who, pulled from the crowd for a special private moment, shared David's hopeless car ride. "Lucky you don't need to drive back down Commonwealth Avenue!"

"I couldn't get more lost!" Pierre-Yves is toasting the joke – a joke on David, who, presumably native to this town, somehow forgot the way to Robert's home in Newton and kept doing circles on Commonwealth Avenue so that it came to appear to Pierre-Yves and Caroline the longest road ever (from the park to Kenmore Square to Harvard Street and then back to Kenmore Square and around back to Harvard Street before a little turn into a shopping mall and then on to Boston College and beyond, should you ever wish to visit Robert, should you ever wish to spend much of your life trying to visit Robert).

"That's not funny," says David with a piece of chicken dangling on the end of his fork.

Robert had David on the phone in an effort to navigate him along the most linear street you can imagine and then he just handed the phone to Laura. He is pretty bad with directions, too. That his former student – who has made such an unintended if original career since he showed up in Robert's MIT lab – gets lost in a small town like Boston confirms something about him. But it is funny, as well, and Robert laughs with everyone else at the table.

He likes to entertain in this fairytale of a home that Laura built because it is so *not like him*. Boredom kept at bay by what others might expect from a home, and no one would expect for him.

Robert works hard around his austere disordered lab and, then, usually early enough to see his kids, he comes back to his extravagant home and it relieves him; because, while invention is fun, it is not easy. Robert works hard – too hard the doctors tell him, which is why, when Laura designed the house, he requested a gym, second floor and down the hall from the bedrooms.

Robert battles as he does on the poorly lit fields of scientific exploration because he cannot imagine doing anything else.

"Another glass?" he repeats.

Aurélie did not count on the tension. They would move to Paris and the worst fear she had was that they would have nothing to do. Her three little boys – 2 4 6 – would be unhappy. Family members would call each week to invite them to the dinners and baptisms and weddings that her years living outside France had kept her free of. That was what she

feared, her version of the expected, expected of her and from her. As she watches her three sons run around the rim of the Luxembourg Garden basin, chasing sail boats, laughing as happily as they ever will be, she turns to David and says:

"Why?"

"Why what?"

"Why are you doing this?"

Last night he finished a bottle of wine just talking about it with her. Already today he has consumed four cups of expresso. He lives like this now, coffee to wake up after a few hours of sleep, alcohol to wind down at the end of the day. He will kill himself, she thinks.

He says it will be better soon.

"You don't need this David. You could play with your boys or do whatever you want to do. You could."

"No, I couldn't. I just couldn't. I don't know how else to say it."

"You've said it."

"Two more weeks, Aurélie."

The problem is that while the artscience dream was good and probably realizable, and many liked it, the rue du Bouloi neighbors rebelled. Yesterday David received a letter from the syndic – the ever vigilant condo association – informing him that the Prefecture had turned down his request for a construction permit. David has no idea how the syndic knew of the Prefecture's decision before he did. Rumors encircle him. The neighbors have come to believe Le Laboratoire will be home to something ruinous as reflected in the work that Aurélie and David have done for years with young artists in the tough parts of the city beyond the périphérique, where Aurélie and David go only to see kids sing and dance and create dream identities. François and Jean-Christophe have battled the lies and fears but Aurélie believes they might not end. She wishes to move back to Boston and escape it – and lets David know she does.

If they can only get to the creation it will be fine, David thinks. He is not sure they will, though, and is losing sleep over it. For which he needs expresso in the morning, and wine to chase sleep at night. And more wine, as sleep progressively eludes him.

Earlier today, the only employee of Le Laboratoire, Vidya, tall beautiful Parisian of Indian descent, asked what would happen if 4 rue du Bouloi falls into litigation. Would they abandon everything?

He told her not to worry about it.

They had things to do. It still is not even clear they have a business.

thermodynamics is the study of energy on a macroscopic scale (meaning some scale that is generally far larger than molecular size) and of a system we judge to be at least near to a state of equilibrium. equilibrium is a state where properties of the system – like energy itself – do not change with time. a bottle of milk (the "system") in the refrigerator is generally in a stage of equilibrium. its temperature does not change. of course, in the morning, when you remove the milk from the refrigerator, the temperature does change. but at least for a long period of time its properties – temperature, volume, pressure – remain constant and so we agree to call this equilibrium. thermodynamics specifies the laws that relate things like temperature to pressure to volume by a careful consideration of the property of energy. one of the most interesting properties of thermodynamics is entropy. entropy is a measure of disorder in a system. as entropy increases disorder increases. thermodynamics tells us that within any 'closed system' a change in energy results in an increase in entropy. this corresponds with our general intuitions of life – and may underlay our surprise at the ordered functioning of stem cells, even at the witness of intelligence itself.

If they can just get to the creation he guesses it will be okay.
He toasts the idea with a glass.

Near the end of his very strange week with thirty two French artists, David, who has started to wonder how he will ever choose from such a fine pool of talent, tosses around in bed trying to imagine a way out. And, here, around three o'clock in the morning, he begins to dream. In David's hopeful hallucination one of the thirty two artists steps forward as the clear candidate to inaugurate Le Laboratoire. His name is Santiago, obviously an odd name for a French artist, but David has perhaps confused the name with that of the Nobel Laureate, Santiago Ramon y Cajal, an artist and scientist back in the day when artists were sometimes scientists, scientists sometimes artists — discoverer of the central nervous system. Anyway, Santiago distinguishes himself from the others by becoming a stem cell. This alarms everyone and naturally sets Santiago apart from the pack.

Santiago, to pursue David's deeply optimistic dream, is then a stem cell. More precisely, he is a *human embryonic stem cell*. Now, a human embryonic stem cell, according to the nifty pamphlet Robert handed to Santiago at the end of dinner Monday evening — Robert, so full of energy, bouncing on the balls of his feet, like this smart ass kid bent on having fun and doing some good at the same time and unaccustomed to the company of those who are not like him or at least do not aspire to be like him — can become *whatever it wants*. That idea seduces Santiago, who occasionally feels this way, too.

But as a human embryonic stem cell Santiago will behave a little differently than before.

What will he do?

More importantly (for by definition he can do whatever he wants), what does he want to do? What does he want to become? That will require some intelligence to figure out. Or, is *figuring it out* the doing, and is *the doing* intelligence?

Stem cells ask those questions all the time.

Or at least they do when within their niche. *Niches* are stem cells homes. When at home stem cells retain their identity and eat and sleep and create more or less as we do in our dreams.

Santiago is a humanist; he believes stem cells are people are nations are the world.

the use of human embryonic stem cells in medical research poses an **ethical dilemma**. only embryonic stem cells hold the potential to transform into all the functional cells of the body. if researchers are to derive from these cells other cells, like pancreatic cells to cure diabetes, or neuronal cells to correct spinal cord injury, they must use, or would at least benefit by using, embryonic stem cells. for human medical applications these must be human embryonic stem cells. but to obtain these cells requires a human embryo in its first days of existence. question: is a 5 day old human embryo human life? question: is it right to use such an embryo, to take its life, to offer the chance of life to a human being, or to thousands, even millions of human beings?

Santiago's niche will be like the bedroom he grew up in with three beds he could choose from, big and spacious and gentle. His niche will not simply provide food and drink and shelter. It will, as Robert and his colleagues – Anderson and Mooney – have so carefully explained, guide him from excess (something to do with cancer) and utter disaster (which in stem cell lingo means depletion, exhaustion, death).

As a stem cell Santiago will need to think a lot about home – about the comfort of it and the sustenance of it and the way it points you into the body, aims you, he intends, to the brain.

Home holds the secret to becoming a neuron.

Is this not like that Dorothy in the movie they called Oz?

Home is the goal.

But why?

Once home, will he have discovered intelligence? He assumes he will. To be a neuron must be the pinnacle state of intelligence.

a stem cell **niche** is a place like what many of us think of as home, a place of productive equilibrium. in the body, often in the bone, it is where stem cells produce new cells, avoid depletion, and are prevented from over proliferation. we can hardly speak of the usefulness of a stem cell without speaking of its niche.

a **neuron** is a cell that looks like no other – with a core center, the soma, home of the nucleus. reaching from the soma are dendritic extensions, as well as a single long arm, or fiber cable, the axon, which can extend tens of thousands of times further in space than the soma itself. at the end of the axon "neurotransmitter" chemicals are released. these are the words by which neurons communicate – the currency of intelligence, whatever it is.

40

The Disaster happened this way:

Caroline left Santiago on his way to New York at Logan International Airport. He was, when she left him, soft, adorable, creative – a stem cell, she assumed, in form and function.

"Cell division is the key thing," he had said, there at the end, while loitering with Caroline in the customs line (she was headed back to Paris) and explaining how it was that by becoming a neuron inside Robert's brain, Santiago, the only artist in human history to have experienced such a thing, would go on to discover the meaning of intelligence. Eventually he would find a way to share what he learned through the opening exhibition of Le Laboratoire.

"I'm sure you're right," she replied, scratching her neck with her worn magenta passport. "It won't be difficult. Robert is excited, anyway. I'm sure it will be fine."

"I see it like falling through a giant hourglass. Whoa!" He squinted dramatically as Caroline glanced anxiously around. "Cell division, I mean."

"Sounds fun," she assured him. "Inevitable. You'll like it."

"Yes, but then?" The line inched ahead. "So I divide. I'm two. It's distortional, fabulous – weird." He pinched his wide eyes again, this time without the sound. "I'm that much closer to being a neuron." He opened his sparkling eyes and gazed into hers with penetration. "I guess I'm smarter. You think so? I mean, to be what I am now, a stem cell with this obvious mission, is to have too many wrong paths ahead of you. What is it to be a neuron?"

"Wrong paths and intelligence have never seemed to me distinct," Caroline said. "Like love and bad boy friends. It sounds to me like freedom." She threw a sharp indignant look at the woman before her in the line, who gawked irritatingly at Santiago. The old lady, dressed in sporty jeans and high heels, had bunches of thin wrinkled skin hanging loose around her jaw and neck, too much sun.

"I don't know."

"It's the brain of Robert that confuses me," she said evasively.

Robert's brain really did mystify her. All those facts and memories of brilliant moments packed inside and yet somehow letting him sleep at

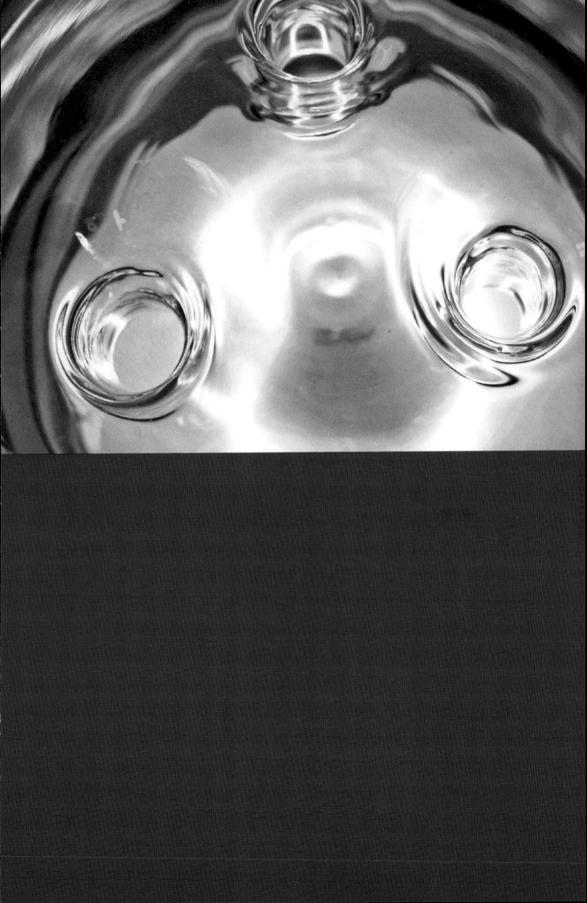

night. But it was something she could imagine. She knew what a brain was, or, at least she knew the experience of thinking, which was what she associated with having a brain, so in this sense the confusion Robert's brain posed for her was a matter of degree.

More stupefying was the idea of cell division. Caroline had tried to imagine it during her first jet-lagged nights in Boston. She thought of it as giving birth. Less painful? Oh, what if it wasn't? You started out as a single biological entity, and, then, in a moment of wrenching unendurable pain, became two. While she had never actually delivered a child she had seen it happen, watched the mess and nearly inhuman thrill of it: inside, your body screaming continually, each cell perhaps looking to distract itself from its pain. Lying there as she did with miserable cold air pounding down on her from David's badly engineered central heating system, she thought more deeply about it. No, human birth was not it. In giving birth you did not split in two. You released someone else. You grew something inside you and then all at once it came out. Like a yo-yo, you stretched and then flicked back to your original state.

Maybe it was like falling through an hourglass.

It had been an optimistic period, those days of Santiago the Stem Cell. What would become of him? What would this first experiment produce as a result? A curious mind like Caroline's naturally asked those questions, like the lab scientist who mixes two reacting fluids and eagerly awaits the outcome. Funny, she thought, taking ourselves for scientists – and Santiago for the experiment itself.

Anyway, ten days after returning to Paris Caroline received an electronic note from Santiago's agent Julie that said:

Subject: He is back!
From: julie@aol.com
Date: 1/22/07 15h22
To: caroline@laboratoire.org

So happy to see him. He has not changed. Not at all. Have no idea what you meant. Stem Cell? What is that? But he is happy. Thanks for taking such good care of him.

Subject: Re: He is back!
From: caroline@laboratoire.org
Date: 1/23/07 8h35
To: david@laboratoire.org

David. Disaster! If Santiago is not a stem cell, what are we? Keratinized by the art world!

44

David stares at the depressing text. Then he lets his gaze wander up over the black polymeric edge of his X60 Lenovo computer screen. Winter rain drizzles outside the window on the Place de Furstemberg. It is late January 2007. The sound of droplets beating on the pavement helps him notice his own biological life. The regular patter of drops pleases him. He appreciates the coolness of the leather pillow beneath his neck, savors the sensations of the moment all the more since corporeal experience (even his own) frequently escapes him. A living, breathing, heart-pumping man, he does not feel as biologically rooted as he believes most of us do. Then, every so often, something sharp (a pleasure, a pain) or unexpected, draws him back. Habit and isolation overcome. And with physical sensation comes remembrance — and, these days — mourning.

Probably Santiago's stem cell journey was a bad idea. The Wizard of Oz was one thing. But did a scarecrow's dream amount to an art exhibition of great urgency? Santiago had gone too far. To experience intelligence in its most primitive form, as a transformation from potentiality to reality, was, David supposes, admirable.

But Le Laboratoire opened in less than a year! It promised (he had promised!) that it would be a catalyst for innovation that relied entirely on the human imagination and the trust you needed to traverse any of those rigid disciplinary boundaries that ran across it, ran across you, wherever you found yourself creating in life. It promised to be a catalyst for innovation of the kind you could not predict and anyone who knew to create knew how mental catalysis sometimes led to breakthroughs and at other times — maybe this one — to nothing at all.

And can you ask the public to celebrate the importance of failure, as savvy creators do?

So here the first experiment had failed. David accepts that it did.

What had been the chances it would succeed? The business model has started to worry him.

The stem cell, if he can refer to Santiago in such a way, lasted just a few days, as stem cells do when pulled from their niche … Sometimes, though, cells, when removed from their biological environment, do not die; they only cease to metabolize at their normal rate, like the tuberculosis bug that gets trapped in the tissue of an Egyptian mummy and three

cell division resembles what happens when a tree produces fruit that falls to the ground to produce more trees. over time daughter trees appear. it is like this with cells – only far more fascinating to observe if you have the chance and a powerful light microscope. in the event, the cell nucleus forms a kind of dumbbell, and then the cell does too, and the entire contents of the cell, including all the genetic material, split in half, creating two identical new cells. stems cells can divide in more complex ways too.

keratin is to the body what chalk is to some parts of the earth – a primary substance of our superficial layer. to refer to something as keratinized is to speak of a process of drying out and death, the last stage before being sloughed off the body.

millennia later springs back to life.

What about that?

With this glimmer of hope, David, who considers himself used to taking risks, may even thrive on it, whips his attention back to his computer screen. He taps his mouse on the little square in the upper right corner of his Mozilla message and opens a second note, this one having arrived at eight o'clock in the morning while David walked his sons – Jérôme Raphaël Thierry – to school through dark empty streets of the 6th arrondissement.

He scrolls the notes from the bottom up:

Subject: Update?
From: david@laboratoire.org
Date: 1/28/07 10h25
To: mathieu@aol.com

Mathieu, lots happening. Where are you?

Subject: Re: Update?
From: mathieu@aol.com
Date: 1/30/07 18h03
To: david@laboratoire.org

David, I've gone through all the NASA patents. Am pretty sure there is nothing like what we propose. Did an experiment, too. Took pictures. You'll see. It works. We need to meet soonest.

Subject: Re: Re: Update?
From: david@laboratoire.org
Date: 1/31/07 3h45
To: mathieu@aol.com

M, I fly Tuesday – LA SF Boston. You around Monday?

Subject: Re: Re: Re: Update?
From: mathieu@aol.com
Date: 1/31/07 9h08
To: david@laboratoire.org

D, not Monday. After you get back.

Frankly, when the Disaster happened, David made a hasty decision. If intelligence was not in the becoming it might at least be in the doing. To become is after all to be open to dispute. You start out as one thing, and you become the other. But did you really become the other? Or was it simply a partial metamorphosis? Does the adolescent ever completely cease to be the child, or does the child ever cease to be the baby nursing on his mother's milk? Becoming is a maddening asymptote.

You are, as Deleuze would say, "becoming-you," or "becoming human."

Doing, he thought, has solid finality to it. You can measure what you do. That was always reassuring. And what you do has stubborn independent existence. If you die, or simply change your mind, the thing you have done does not cease to exist. Of course, he suspected, there might be a philosophical flaw in there. There usually was in most things. Should he let that stop him from doing? To distract himself he took to repeating the word like a mantra: Do do do. It appealed to David's American roots.

Mathieu proposed to make plants more intelligent. He did not question what intelligence was. He simply gave it a reasonable definition. To be smart, as a plant, according to Mathieu's definition, meant to pull noxious gases like benzene and formaldehyde out of the air and break them down, chemically speaking, all while maintaining an unchanged readiness to pull more noxious gas out of the air. Plants do this all the time. It is obviously smart of plants, since humans who call themselves smart design filters, which they sell to significant profit, in their effort to clean dirty air and, then, the filters inevitably clog. Exceptionally smart humans make filters they eventually throw out, being dirty, and, thus, while they clean the world in the short term, they dirty it in the longer term. So they fail. Plants do not. They really do clean things up. This is smart of them. It is intelligent of them – at least in human terms, which seem to be the only ones we know to use.

Mathieu decided to design an object that would increase this intelligence in a measurable way.

Fine, David said. How did Mathieu propose to design such an object?

Mathieu told David a story:

NASA scientists had, back in the 1980s when Mankind believed it might explore the universe in sleek space ships and dock for respite at space stations with limited precious air, looked into how plants pulled gases you did not wish to breathe from the air you needed. How would

Mankind survive adventurous living if it did not have a way of making the air clean without eventually making the environment dirtier? This seemed to be a good question at the time. Some at NASA saw it as pressing. Thirty years passed. Nothing much came of the NASA research – aside from some interesting articles. Meanwhile, the earth's atmosphere accumulated gases faster than anyone ever supposed it could. It came to appear to anyone who paid attention that we would more likely choke on our own foul gaseous excrement not while exploring the universe but while watching reruns of Desperate Housewives – that unforeseeable invention our cells had developed to distract themselves from the pain of their unending division.

Anyway, Mathieu wanted to filter the air using what the NASA scientists had learned.

David looked into it. He called his former Harvard student Jonathan and said: Pull the patents. Pull the articles. Let's see what they did back in the 1980s. Well, they had not done things quite so perfectly. NASA had not really made plants smarter. They had cleaned the air with fine particles of carbon – charcoal, in essence. But carbon gets dirty. Plants do not get dirty, since they metabolize the gases and turn them to useful purposes so that nothing goes to waste. This is what makes plants smart, with the potential to get smarter, and, so, it became the focus of Mathieu: How to make plants pull gases out of the air to their benefit and the benefit of everyone who inhales.

As for Santiago, he is in the doldrums. Our dejected artist, formerly a stem cell, wanders aimlessly into the wash closet at the far end of his white studio. The air is cool, the way he likes it in order to be his most creative self, which, he recalls with bitterness, is completely contrary to the way a stem cell likes it. Santiago works at about 15 degrees Celsius below what just a month ago made him sing with joy.

It seemed so permanent, his breathtaking cellular change. He slept little, which was hardly new for him; only, then, in his Stem Cell Manifestation, sleepless nights had not bothered him so much. His head had been like a furnace of ideas. They had poured out like the water presently falling out of the faucet over his paint-speckled hands.

Some of those ideas remain fresh in his head, notably those that contrast human living with stem cell living, those that establish the stunning familiarity between stem cells and creative humankind.

To be a stem cell was, he surmised, to be immersed in a bath, like

to **metabolize** is to absorb nutrients from the environment and transform them into the energy that drives cellular life. it is like what happens when we eat food. cells, like us, metabolize at a rate that varies with things like temperature. at body temperature cells metabolize effectively – but cut the temperature in half and the metabolic rate goes down. we're like this too. indeed, scientists have begun to learn that organisms that eat less live longer, or, put another way, eating less tends to help an organism live longer. not surprisingly, cells are like this too, or, at least we notice the effect in certain kinds of cells. the tuberculosis bacterium is very hardy in this way.

the bath of champagne his friends gave him for his 35th birthday – and five minutes of frolicking had left him stoned. Cells sit in fluids and live in them and get drunk occasionally too – according to Robert. To be a stem cell was equally to enjoy a long delicious meal, like the lunches Santiago makes for his friends in his atelier, where they spread soups and fishes and bread and wine bottles over a big studio table and forget the day. Stem cells feast without end, sitting in a bath – as if they needed to forget something.

For to be a stem cell was, even more than this, to anticipate that cataclysmic moment where chromosomes rearranged and assumed the tell-tale form of an X. He is getting a little technical here. But according to the literature Robert passed on to him, and that Santiago read one Boston evening after dinner in his bed, this is precisely what takes place just before you double. Double … The notion is absurd. It is as if a red car were to become two red cars, or become a red car and a blue car, or become two blue cars.

Diversification, something Santiago previously envisioned as applicable to the entire species, becomes a thrilling individual experience. In a flash you are the future of the goddamn human species itself! Except that you aren't exactly you – words obviously fail you in the diversified state.

To be a stem cell was, therefore, the anticipation of that moment of doubling even though Santiago stopped short of knowing it.

One day the hope (and fear) of total gut splitting transformation left him.

The Stem Cell disappeared!

Where did he go?

When did the old Santiago reappear?

It might have been on the plane to New York City, or it could have been in the taxi headed to Little Italy. Maybe it happened one night in his San Francisco hotel room. Santiago only knows for sure that by the time he returned to Paris he stumbled into Julie's thin outstretched arms like some pathetic multi-cellular blob.

The creak of a swinging metal door sends Santiago hurrying ahead as impatient Julie does something to distract herself in the kitchen.

Caroline strolls smilingly into his atelier – "Hello! Hello!"

Santiago points wordlessly at the three white canvases propped

osmosis produces water flow across cell membranes approximately as a zone of high pressure blows air (the fluid) through windswept trees (the membrane). by osmosis cells shrink and swell like blowfish. this helps them pursue various essential biological processes.

against the walls between the kitchen door on the left and the wooden stairway on the right, like a cupped hand ready to close its fist around him. Words rarely escape him like this.

Caroline's smile fades. "For today?" She is not sure what to make of it.

Tall handsome Olivier, looking sharp in his blue jeans and black boots, enters the studio followed by smart aleck David. Santiago looks down at his own boots, light brown leather, while Julie wanders into the atelier from the kitchen.

"It's all up here," quips Santiago, smiling in that toxic way he excels at when impatient for the passage of a moment – in this case the moment of David's arrival. He points a little defensively at his temple. "Let's go for lunch." He picks his coat off an orange chair and flings it over a shoulder while seeing more clearly than before how the fault is not his.

Fireflies differentiate in real time. Not humans. Differentiation of the species is theoretical, something you can hypothesize by studying bones, artifacts, DNA. You do not experience it.

David said you could. The secret was collaboration, David explained. Perhaps every creation that had ever happened in the history of the world and that mattered at the same time could be traced to collaboration. You did not always mention it, but it was there, human contact in relentless pursuit of the innovator.

Einstein or Hugo, it did not matter – they had all invented in their own ways because they experienced civilization for years, read what others said, sifted through human experience to arrive at ideas others cared about and had even thought about before these great innovators did. Recognizing the value of their ideas to civilization they passionately translated them over obstacles to realization.

Santiago walks down the street with David (they laugh and pat each other on the back trying to regain a certain feeling) wondering if you can place the catalytic surface of cross-cultural collaboration in front of a man and count on him to step on it. Santiago did, in any case, step on the surface, but, then, unaccountably, he stepped off.

Why? He stopped believing! He assumes it is that simple. David was gone, Robert was gone: the idea looked preposterous.

There is another thing, too: Santiago has many other fine creative projects. How can he do them all?

Later they are back at the studio. Olivier, Caroline and Julie find random places to sit and watch.

It is something like a duel. Santiago stands before a white canvas

with a piece of black chalk in his hand while David remains aloof.

"There were two ideas." Santiago rapidly sketches two human shapes. His ideas are like bullets to be dodged before firing back.

David says, "It was your impression of natural versus artificial cell environments."

"No, no it was not." Santiago's voice is as cold as the pistol of his brain. He has decided that if David fails here it is over. "That's not how I remember it." He continues to draw, teeth pressed tight, creating with a few lines a bath and a table with the resemblance of food on it. These are the easy parts, the parts he always thinks first about.

"You had in mind the biophysical and the biochemical …" David adds.

This seems new to Santiago. It might not be. Maybe he just forgot the words. Anyway he is pleased to remember them. "What did you say?" There is a kind of apology in his voice. He looks openly at David, like an invitation to continue.

David holds his bearded chin in his hand. He does not seem to pay attention to Santiago. "Stem cells are like us, they need food and shelter."

Santiago adds, "And friends." He draws flowingly. He cannot pause. His fingers chase after new thoughts not wanting them to escape him this time. "We're just like cells. And I was a cell. A stem cell." He goes on talking as he draws. "I was young and without anything realized and everything open before me."

"Yes and no."

"What?"

"A stem cell cannot become a stone, a book, a plane. It becomes something – and that was the problem, Santiago. Not knowing, you lost the stem cell. We lost the stem cell. You needed to know more." David wants to relieve Santiago of guilt. Empty the room of guilt that foul dank stuff that snatches words, distorts their sound, stops thought. David must make himself a therapeutic plant that can clean the air for Santiago and him to work in. "A kid absorbs his future as he grows up and builds it for years even before he sees it and you didn't have the time."

"Say what you mean."

"You didn't know about progenitor cells. On the way to becoming a neuron you produce a cell that has no purpose other than to become something else. We call it a progenitor."

"Sounds like an adolescent."

"And you don't know what a neuron looks like either. That's

another thing." David stretches a hand out toward Caroline. "It's got a long arm, a cable called an axon, and it is what passes information from one neuron to the next."

Santiago walks over to David and gives him the black chalk, saying, draw it. The artist he was a moment ago, his mind distracted by too many ideas, he no longer is. He might become a neuron, which David painstakingly sketches on the board. Or, not – it remains unclear to him. More clear to him is that at this moment he might become whatever he wishes, and not become what he wishes at the same time, for the one half of Santiago might indeed find his niche, and the other half not, the one half going on to discover intelligence, and the other half minding all those personal and creative and merely administrative things Santiago will need to keep track of if he is not to let down Julie and the world. No, he is not the stem cell – he has moved on.

Might he be a progenitor cell? If so, he is actually two cells. Yes, he has split in half.

Olivier sits on the stairs with hands clasped around his knees watching. Before this he had no idea what a cell looked like, how a cell behaved. Cell was just a word to him. Caroline hopes for Le Laboratoire. Julie is warily stunned.

The canvases are by now full of black chalk.

"Here's what I'll do," says Santiago, leaning back against the chalk.

"I'm listening," says David, eager encouragement in his voice.

"I'll make two drawings and you'll bring them to Robert. Two human bodies. They'll be skeletal images – something like this." He nods at one of the panels.

"Okay, easy to do."

"You'll ask Robert to create from them, to transfer in a way what he knows, what he knows of Man's Attempt to Alter Stem Cell Living to Make Biology Better than it is. Anderson and Mooney will help him."

Robert will in this way create Santiago's niche, like the Yellow Brick Road that leads to Robert's brain.

Robert eats his Corn Flakes in his 1% pasteurized milk at the kitchen bar. In his right hand is a milky spoon, in his left a Blackberry. He listens to Laura talk of Sammy's ice skating lesson while reading some of the fifty two notes that arrived in the night. People know Robert all over the globe. He sees it every morning on his Blackberry: Japan Thailand China India Russia Israel France England Italy Belgium Holland Germany. He

scans rapidly with his thumbs. He will not have time for all the messages – perhaps a hundred a day. His secretaries (he has three) take care of the rest. He prefers answers like, "Yes," or, "I agree," or, "Let's talk," or, "Good idea will follow up at the office." He sends pithy notes about as certain good card players shoot spit.

"Got a note from David," he quips to Laura, glancing her way to gather her reaction. Normally Laura does not generally care about Robert's correspondence. She has other things going on in her mind – a bright active woman, Laura. "Santiago loved meeting you. Very impressed by your French."

"That's nice," Laura says politely. "Okay Bob, I'll be back. Gotta run. Have a good day. Susan and Sammy waiting for me in the car. Bye!"

Robert nods with his head down. "Sounds great," he writes, when he has finished. He would add other things in this email to David were he to believe in prose more than he does. He would write that he misses the kind of collaboration he knew when as a young scientist he worked in the laboratory of a brilliant scientist named Judah with an integrity – was it this? – that made you wish to invest everything you had in what you did. Work was not just the chemical manipulation of polymers that eventually made Robert famous.

It was dreaming, dreaming with testing, dreaming with daily deceptions. The scientific work Robert came to love back then was a dream you tested and evolved whatever came of it until you finally realized a dream, a new hardier dream, and through realization you learned something about yourself and the world you lived in.

This is what Robert trusts: a way of following dreams that is intuitive and analytical, imaginary and real. He calls it science. It is a rarefied form of science, the kind that changes the world and what we think of it. He has spent twenty years doing this kind of science and formed more than a hundred students as professors around the globe and yet he can count on a single hand the number of occasions he has had to collaborate with a dreamer.

He pushes "Send."

The magical creation of Santiago's niche begins with as little ceremony as that.

As one experiment heats up in Cambridge, another, on the other side of the Atlantic, begins to produce something near a result, a first indication

polymers are like chains with iron links. single links, or molecules we call monomers, are sealed to other links by chemical reaction, like solder. polymers can be natural or man-made. many of the molecules of our bodies are polymers, including all the molecules we call proteins. biomaterials made of polymers appear to the immune system as if they belong in the body so that the immune system leaves them alone. biomaterials are then designed by the scientist to produce a local environment that will cause the biology to behave in a way that the scientist wishes. in this sense cell engineers design niches as we have tried to design le laboratoire.

of intelligence. It is a mid-morning day in early January. Sun rays soar over the irregular rooftops at the east end of rue de l'Abbaye, facing rue Bonaparte, splashing finally across the worn dusty parquet of David's apartment.

David:"There are three principles." He points professorially to the drawing he prepared before Mathieu's arrival this morning. A puddle of light bathes his black clogs.

Mathieu:"I don't see the second. It makes no sense to me."

David: "The air needs to hit the leaves first." He points to the tripod. "Then the soil. Hitting the soil first isn't natural. It isn't how nature works."

Mathieu:"That's not an answer."

David: "Air that goes through dirt comes out dirty. We're trying to clean the air."

Mathieu:"That's an answer."

David: "Now draw something that looks right. I don't know the first thing about drawing – or plants. What plants are we talking about, anyway?"

Mathieu: "Funny you can make more intelligent what you don't understand."

David:"I do that all the time – I'm a professor."

Mathieu: "English Ivy, Mass Cane, Chrysanthemums, Ficus ... Your students." He sketches across a new sheet of paper draped over the tripod. His lines are quick and confident, the efficient work of a particularly effective neuron linking brain to fingers.

The NASA scientists had no chance. No fast hand, no Paris sun – no artscience.

But how will any of this ever matter? How, to dream a little, will it enter, without complete embarrassment, the annals of art and design exhibition history? How will the experiments David loves be translated into material that is recognizable if not always charming? These are the sorts of questions that hover this afternoon over a corner of the smoky dining room of the Café de l'Epoque.

They are all here, the Lab Team, twenty meters from the ruin they call (with stunning hopefulness) Le Laboratoire. They have spent recent years elsewhere: Olivier (in Turin) Henry (in Berlin) Caroline (in Lille) Noëmie (in Lenz) and Vidya (in London). Having abandoned rational

artscience is that world of intellectual process where creation follows a mixture of intuitive and deductive paths.

careers in culture and healthcare and business, they intend to pursue the wild Lab Promise, which, if one of them were to state it plainly over their two little round tables, would be something like this:

Art will appear at Le Laboratoire less an end than a process of innovation and discovery that leads to that end; culture less possession, or patrimony, than expression and dialog; industry less economic engine than civilization rule-setter; education less teaching what is known than learning what must be known if the accelerating world is not to pass everyone by as it careens to disaster.

Well, yes, there remain perhaps one or two deep and sobering questions. To begin with, nobody in this café, or at least no one sitting beside these two round tables, has ever started an organization before. Launching a cultural organization has even less precedent. Winds having changed since the exciting days that preceded Malraux, the prevailing Paris climate does not exactly invite the association of risk with culture. The last startup to have made its way into this part of the city was probably the Comédie Française, which moved into the Palais Royal about two centuries ago. As to the climate of innovation, it is a little like Spain in the days of Don Quixote.

David arrives thirty minutes late. He rushes up the street with comical Quixote spring, as if each step were to make a point, announce the terms of success. Here is what they are (he repeats these things to his team on a weekly basis):

- The artists must get it
- The scientists must get it
- You must get it
- Our partners must get it.
- If all the above get the purpose of what we are trying to do here then the neighbors must get it. Among our neighbors – presiding over the ghosts – is the Minister of Culture.
- We have less than a year. Good luck.

The instant he sees David, Henry gets to talking – he speaks English, gets by in French, and speaks fluently Dutch and German and some Swahili too. His topic is the first artist-scientist experiment he will guide at Le Laboratoire. It is about preventable deaths that the world is somehow not preventing, a matter that relates to intelligence perhaps only in intelligence's stunning international absence. The renowned art photographer James will work with Anne, scientist founder of an AIDS and TB clinic in Cambodia – and other artists and scientists around the world – to explore what should be done as opposed to what can be

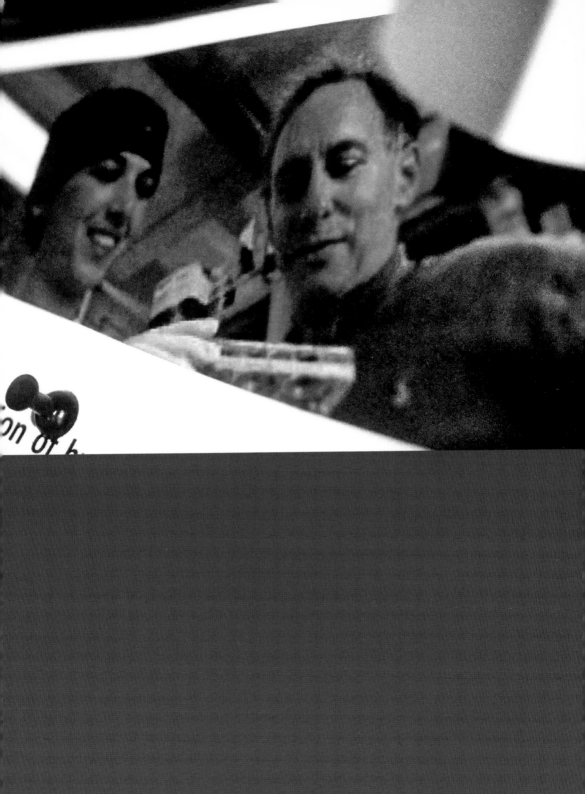

done given the current resources and knowledge base.

David sits down. Glasses move rapidly around the table, plates of ham and pâté arrive and leave with little bits of pepper on them, the conversation falls into matters of philosophy. It is all complicated to summarize, though essentially the point becomes this:

- When art meets science it catalyzes innovation in culture.
- When art meets science it catalyzes innovation in industry.
- When art meets science it catalyzes innovation in education.
- When art meets science it catalyzes innovation in humanitarian engagement.

Back across the Atlantic: A couple months have passed. Time is ticking away. David, who is expiring from all this air travel, writes "They're here!" in the Thursday morning email he whips off to Caroline from Cambridge. On Friday he is in New York City where he picks up Daniel – the art photographer – and by mid afternoon he is back in Boston.

An hour later he is on the phone with Aurélie back in Paris while looking out the window at the John Hancock Tower. He feels well – all the more since this morning he half thought he might die. They talk for thirty seconds when the bell rings. "Gotta get the door," he offers as he hurries into the next room. She is quiet. "Aurélie. I'm really sorry. The food is here. Just a second." He pushes the button that opens the front door.

"Call me back," she says.

"There, it's open. No, go on, I'm listening."

"No you're not. You're not listening."

"I am."

"No."

The elevator door opens.

"Hello," David whispers to the man inside the shaft who holds two heavy insulated bags. He covers the receiver to say this, as if hoping Aurélie will not hear him. "In here." He points with his free hand to the kitchen while with the other hand he puts the receiver back to his cheek to say, "It's all set." Of course, Aurélie does not believe this, as he would not believe her were he where she is, in a Paris apartment, and were she

Spider Plant
Anthericaceae

catalysis is like lighting a fire with matchsticks. we begin with no fire — however once it exists the fire continues to burn freely. getting the fire to exist requires energy, some effort. the matchsticks make that effort conceivable. we do not need to painstakingly rub sticks together - a strike of the matchsticks will do. they help us surmount obstacles to creation. as a consequence something shines that did not shine before.

where he is, for the tenth stretch of time in nine months, trying to hold this experiment together, hold it together just one evening longer. "I'm here for you now."

"Just finish with him. Okay?" She will make an effort not to get angry. He last called her about three hours ago while in a taxi headed to LaGuardia. Daniel was sitting next to him when a tunnel cut the phone connection. Before then he had been in his hotel after a few hours of sleep and spoken in short staccato sentences with a kind of unwilling irritation. Was it worth it? He had wondered that then, probably said it many times over the phone. She adds, "I'm not talking."

The doorbell rings again as David lead the delivery man back to the elevator and this last bit of chaos dooms the call. There is a click on the receiver. David cannot remember when she last did this if she ever did.

In the little camera next to the refrigerator he sees Xavière and the film maker Jared before the door. He lets them in and, a minute later, points to where they should put Santiago's drawings and then he runs upstairs to the bedroom where he calls home in Paris and then he has a good laugh with Aurélie and she wishes him good luck, and David says he will need it, the luck. It is an important night, the most important. He thanks her. Without her he would not be here.

Four scientists – Robert David Anderson and Mooney – pass an aesthetic evening creating together as Santiago eats pizza in Paris with his cell phone on the tabletop. There is no other experience like this in Boston, nothing like it in New England, nothing like it on the entire East Coast of America. Possibly there is nothing like it at this particular moment anywhere on the entire surface of the earth, in the universe. Elsewhere, scientists listen to music, watch ballet. Perhaps they play music together, or recite poetry, or discuss their opinions of Dos Passos. There are many scientists who create this evening with purely aesthetic aims. They make books and music and dance and forms of expression we do not even know to call art. We do not call them artists, in most cases, not that it matters. These other scientists, or artists, or artscientists, do not however collaborate around aesthetic goals. They collaborate around "scientific-method" goals in roughly the same way artists collaborate around "aesthetic-method" goals. This is because while art and science pose no insurmountable barriers to individual creative initiative, *collectively* (and for much the same reason that while two dust particles might collide in the air around you, the chances of four colliding is almost zero) they remain experientially separate universes. David smiles at the realization

that they have momentarily altered that.

Robert leans over the skeletons. Aviva and Chi-Chi – two special students at Harvard who volunteered to help out, to think differently about their futures – have placed them in the center of the floor surrounded by reams of paper filled with equations and pictures and obscure words. Mooney leans over at his waist, hands deep in his pockets, searching for something.

"You know," says Mooney, standing up straight with a half smile, an idea forming clearly enough that he feels right about sharing it, "making a neuron out of a stem cell is like creating an ice cream sundae."

"Go on," says David, hurrying to the couch over the papered floor. He wants to sit down, catch the idea with his feet up.

"You start with vanilla," Mooney goes on. "That's the stem cell."

"Vanilla, right," repeats David.

"Then you add what you want. You decide what you want and you create something new. That's the neuron - the sundae. What do you think?"

"I like it." David gets to his feet. The moment of repose lasted maybe twenty seconds. "To the kitchen," he orders, pointing an authoritative finger. "Let's go!" He takes the cameraman by the shoulder. "Jared, come on with us."

A few minutes later they all stand around a black bowl in the kitchen. David has placed old ice cream on a plate with some chocolate chips, some strawberry jam (the refrigerator is practically empty), some nuts. Robert scoops the ice cream into the bowl. Then he adds the chips. Jared films it all as Mooney un-corks a bottle of champagne. Anderson swings into the picture to toast the fudge sundae, with Daniel leaning with his camera over the ice cream.

"I think I've lost my appetite for ice cream," says Robert, looking dully at the sad creation.

"Though not champagne, I see," adds David. "Still going to swim in it?"

"With Santiago!" Robert is triumphant as they all laugh and drink more champagne. "I will," he swears, shaking his hand.

David picks up the phone and dials Santiago's number: "Hi, it's me. They've done it. You'll like it. Your niche. It's like a fudge sundae."

Santiago sits in a restaurant in the 10th arrondissement eating pizza. He wants to know if it can be strawberry, the ice cream.

David passes the question to Robert, who shrugs, champagne in his hand. For thirty years he has done scientific research. But never has it

occurred to him to cover wood parquet with it. Never has he translated it into ice cream. He does not need to understand why he has done these things. But he must go now. He is already late for a meeting.

The drawings get shipped back to Paris. The pages and pages of scientific artifacts travel across the ocean, too. David passes an early evening with Santiago explaining some things – and after this Santiago is on his own.

Cell division, he tells himself each morning when he awakens, is an agreeable thing. There is no conflict in it. Before, when he had thirty ideas inside his brain, he felt torn – sometimes to the point of paralysis. Now, only vaguely cognizant of the other Santiagos who pursue their own activities, wherever they are, he skims through scientific articles without the slightest regret for what he is not doing. Forget everything else! Santiago will be the dogged scientist! His single goal tonight is to ascertain the essential signs to be followed along his Yellow Brick Road:

> *Neuronal Stem Cells Can Develop Into Functional Neurons.* Science Daily: Researchers find that neural stem cells, isolated from the brains of adult rats, can mature into functional neurons.

No, no, that's not it, he decides. He flicks shut the Google window.

A *neural* stem cell is *supposed* to create neurons. You know it will. He rolls his eyes. It is something like a tennis shoe factory making tennis shoes, or an athlete running a race. What is newsworthy in that? You may be pleased it all worked out but you are not surprised. If you needed to fight a fire, not make shoes, not run races – the shoe factory and the athlete would disappoint you. The neural stem cell is like this. It is not an innovator, not totipotent. Embryonic stems cells are totipotent, capable of anything – like happy children and crazy adults. He quickly googles another article:

> *Neural Progenitors from Human Embryonic Stem Cells.* The derivation of neural progenitor cells from human embryonic stem cells is of value both in the study of early human neurogenesis and in the creation of an unlimited source of donor cells for neural transplantation therapy. Here we report the generation of enriched and expandable preparations of proliferating neural progenitors from human ES cells. The neural progenitors

Neurotrophir

Scheme 1

HO—⌇—OH HO⌇—O⌇H

25 minutes / 120°C 25 minutes / 120°C

1 hour / 0.3 mmHg / 160°C

Scheme 2

HO⌇—O⌇H

1 hour / 160°C

HO⌇—OH HO⌇—O⌇H

25 minutes / 120°C 25 minutes / 120°C

1 hour / 0.3 mmHg / 160°C

PEG

PEG Macromer

UV

the aesthetic and the **scientific methods** are like the hare and the turtle. the one races ahead by leaps and bounds, the other plods along more surely. racing and plodding have their own benefits; creators generally do both.

could differentiate in vitro ... When human neural progenitors were transplanted into the ventricles of newborn mouse brains, they incorporated in large numbers ... and differentiated into progeny of the three neural lineages. The transplanted cells migrated along established brain migratory tracks in the host brain and differentiated in a region-specific manner ...

There is nothing in the abstract to this scientific article that escapes him – or, if there is, he does not pay it any attention. Like a good scientist, he concentrates on what he knows. Three key experiences are what he must know on his way to becoming a neuron. First, there is the man-made niche, the context, the home away from home. Second, there is the content – the differentiation, cell division and diversification, the creation of new cells that have unique qualities relative to their parents. He smiles with smug self-recognition. Thirdly, there is the information – the migration, the social interaction and congregation, and the sensitivity to local signals.

He sees it! Santiago is on his way to becoming a neuron! How delightfully simple!

Switch Back to Mathieu: Rumors have been swirling around that Santiago has turned into a stem cell, or a neuron, or something in between. The confusion over what he has become – for the reports are contradictory – is not nearly as troubling as the idea of cell-hood itself. And Mathieu may be more troubled than most, since, if Santiago really has made the cellular switch, Mathieu is as alone as a leaf in his search for intelligence. To "become" may indeed encompass the experience of intelligence but to become a cell is to lose the sense to tell anyone what it means!

Fortunately, none of this confusion has deterred Mathieu. Recently he has performed various visual experiments with plants sitting inside plastic bags and Tupperware boxes and vacuums pulling air through them. It has all worked out fairly well. No, the results have not been perfect, not anything near to what he needs to discover intelligence itself. This points to the negatives of the "to do" approach to intelligence. When you do anything you are liable to measurement by a standard. This raises the chance of failure. Not just one failure, but many failures, since doing anything worthwhile will invariably require constant adjustments. Each adjustment, which follows each failure, leads to a new form of your idea, a

to be **totipotent** is to hold the future in your hands. every potential is yours. it is an ideal more than a reality, an expression of theoretical possibility.

new test - another failure. Your idea evolves this way – as you run from the failure that is ever only an idea away. To be may be good or bad – may be confusing as hell - but it is never wrong.

And Mathieu has failed. There, he has said it. He worries about plants drying out, about air remaining dirty, about designing an object that makes plants no smarter than they already are. There is even the chance he will lessen their intelligence! Were he Santiago he might avoid the finger pointing. You might agree or not agree with whatever Santiago does with this elusive idea of intelligence, but you will not have the chance to say he is wrong.

Yesterday, Mathieu went across the river to see David about his project. Here, he said, showing David some pictures, it works, sort of. We can direct the air other than NASA did and the soil lets us do it. But there are these problems. He showed the pictures, the numbers, the irrefutable discouraging facts. David rubbed his stubby beard. Don't sweat it, he said. I've thought some more. You're going to need a bath of water in this thing anyway, something to clean up the air after it comes out of the soil, eventually dirtier than when it entered, and if you soak up the dirt in water, which gets taken up by the plant, as you also clearly need it to be, you will have not only solved your problem here but done what the NASA scientists couldn't figure out to do. I think you're about there. Congratulations.

So Mathieu, feeling uplifted by this scientist talk, went back to his studio and told his team he would need a couple weeks to work on it. In this period he would not come as regularly to work, would not be reachable by phone, and only rarely by email. If his team would just leave him alone for some days and manage to work independently he would be back with a design that revealed a novel interpretation of intelligence.

It is evening. Mathieu is feeling well about the resolution of this afternoon if far from certain how he will actually deliver his intelligent design. Cécile and their 20 month old Andrea are doing dinner tonight with Cécile's parents to give Mathieu a little space for reflection. He spends the evening walking from room to room hearing little Andrea's adorable laughter, Cécile's laughter, the noise of life.

He walks into his bathroom to brush his teeth. Standing before the mirror, he hears a voice. Thinking it is only in his head like the other voices this evening he ignores it, covers the end of his toothbrush with toothpaste. Then he hears the voice again.

"Hello?" he says. "Is someone here?" He looks around the cramped dank bathroom to his left and right. "Cécile?" He half steps out of the bathroom.

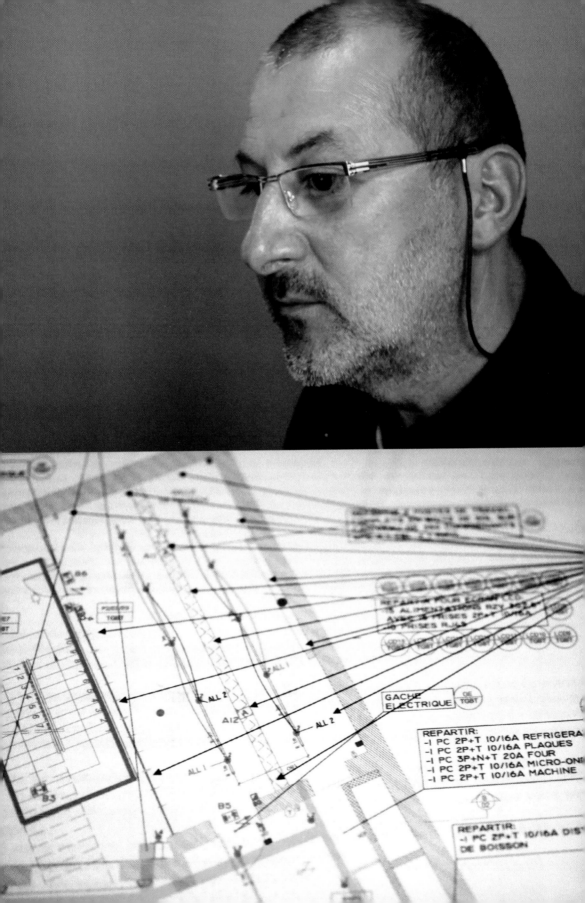

"Wait," says the voice.

Mathieu stops and looks back into the sink. "Who said that?"

"I'm Santiago."

"Santiago?" Mathieu says. He puts his toothbrush under the mirror and places both hands on either side of the sink, looking down. "So it is true. You are a cell. And you are stuck in my drain."

"I am not just a cell, I am the most prolific of organisms, and you will regret my presence."

"I already do," says Mathieu, darting quickly through the door and slamming it behind him.

Twenty minutes pass. Mathieu ends up in his kitchen with a fly swatter. There is the sense that Santiago could be anywhere. Sweat streams down both sides of his face, even though it is cold in his apartment, the steam heat completely ineffective with the temperature falling as low as it has tonight.

"You're a failure, Mathieu."

"Where are you now?" Mathieu is thinking he must be going mad (the voice, the prosecutorial message, the intimate familiarity of it — everything points the same way).

"Over here."

Mathieu looks at the kitchen sink. "You've moved through the drain system."

"Cells need water. There's lots of that in here."

Mathieu opens the faucet wide and lets the water pour.

"Drown, Santiago!"

"Sorry."

Mathieu looks over his shoulder. "Where are you now?"

"You just aerosolized me."

"What?"

"I'm floating over your left shoulder. Failure, Mathieu, I'm telling you. You might as well die. It's over for you."

Madness, Mathieu comes back to thinking. How many unhappy persecuted men have heard these same words? And who speaks them? Is it a ghost? Is it a cell? Or is a ghost a cell?

But it is not his cell ...

Santiago — or whoever it is who stands here in Santiago's studio, feeling like Santiago — remains completely unaware of the drama unfolding in

cells become **airborne** through the process of aerosolization. this is how influenza viruses travel during flu season, how tuberculosis bacteria drift lazily through an open summer window.

Mathieu's apartment.

Having diversified through art all the way into neuron-hood, as he has, or at least as he supposes he has, sees, or feels, or knows just as surely as you know the color of your mother's eyes, the four crucial steps involved in the experience of intelligence.

Here they are:

First Step: You start by drinking and eating. Think of your standard nutritional routine: fruit, vegetables, some meat and milk and lots of water. Since cells are us and we are cells, how could their diet differ from our own? Whatever we eat, our stem cells eat. We and our cells are one. We like apples, our stem cells like apples. Our eyes go bad, our bones get brittle, our skin tints, our hair falls out, our kidneys malfunction, our heart weakens, our muscles fray – lest we eat things like potatoes, oranges, bananas, nuts, cauliflower, broccoli. We eat so that our cells can go on swimming through the blood to get wherever they need to go.

Santiago figured this out however it is that artists figure things out like this – not through deduction – that very first week with Robert. The arrival of the canvases from Boston helps round out his ideas. This, too, involves something other than deduction.

What strange aesthetic productions are these canvases covered by scientific articles and graphs and microscopic images! Had Santiago studied biology and engineering for twenty years, probably he could not have made them. They are Robert, the residue of Robert - Robert tossed with care by Anderson and Mooney short of scientific reason onto a couple of Santiago drawings.

Santiago eats it up. It is his first step.

Second Step: You sleep. Cells get tired like we do. They need to put their feet up, relax, slow down. We like firm mattresses, warm blankets, a fluffy pillow; stem cells have their preferences too. Santiago guessed all this right away but it took an article by Robert and his colleagues to figure out what those preferences actually were.

Nanoliter-scale synthesis of arrayed biomaterials and application to human embryonic stem cells – was the title of the 2004 Nature Biotechnology publication. It read: "Design of a cell-compatible … polymer array required that: (i) a large number of biomaterials be synthesized in nanoliter volumes, (ii) polymer spots be attached to the microarray in a manner compatible with those materials … ; (iii) cell growth in the spaces between different polymers be inhibited … ; and (iv) the array be in a format that allows simple … assay …"

The idea here was to make a bed for stem cells with options. This

reminded Santiago of his childhood bedroom with three beds to choose from depending on his mood. Later in the paper Anderson and Robert explain the best polymer for creating their bed for human embryonic stem cells.

Santiago scribbled it down on a canvas. Beneath the information he drew a bed. The second step …

Third Step: You divide. Santiago experienced this, too, before he knew what it meant. It was not really an hourglass experience. It was more elastic than this, as if your body were to be torn in two (which it was, actually) and transported to two separate universes.

Then he googled "cell division," and read the Wiki definition: Cell division is the biological basis of life. For simple <u>unicellular organisms</u> such as the <u>Amoeba</u>, one cell division <u>reproduces</u> an entire organism. On a larger scale, cell division can create progeny from multicellular organisms… Cell division also enables <u>sexually reproducing</u> organisms to develop from the one-celled <u>zygote</u>, … And after growth, cell division allows for continual renewal and repair of the organism. The primary concern of cell division is the maintenance of the original cell's <u>genome</u>.

The genome?

He read more: The genome is the totality of genetic material of an individual or species. Genes are just a part …

He grew lazy and skipped to a pivotal paragraph: Multicellular organisms replace worn-out cells through cell division. In some animals, however, cell division eventually halts. In <u>humans</u> this occurs on average, after 52 divisions … The cell is then referred to as <u>senescent</u>. Senescent cells deteriorate and die, causing the body to age. Cells stop dividing because … bits of DNA on the end of a <u>chromosome</u> become shorter with each division and eventually can no longer protect the chromosome. <u>Cancer</u> cells, on the other hand, are "immortal."

Santiago finds this last sentence troubling. He understood the power of stem cell-hood. You divided and divided and did not grow exhausted in the process. But you were not cancerous.

Were you?

Fourth Step: You became a neuron. As a neuron you talked more than you thought. Thought was the job of a millions of neurons. So there was nothing intelligent with being a neuron. Talk talk talk. Santiago spent all day on the telephone, or surfing the internet, and often both. The objective of neurons being to transmit signals to other cells Santiago became, as a neuron, even more communicative than he already was. But with whom? Where were his sons and daughters — or brothers and

sisters? If he had divided why could he not find his other selves?

Anyway, while being a neuron was not intelligence, becoming a neuron had certainly made Santiago smarter than he was.

He discovered the meaning of intelligence. It meant to understand what you are not. To understand what you do not understand by being who are you.

It is like a game of chess where each piece-neuron aims to share discrete information with a piece of another sort some long distance from it. The most successful communication transforms you into the other piece, and you become the other, and see the other become you. The players of this perverse game wish to be most intelligent, in a sense, by most quickly transforming their pieces into the other, by becoming most rapidly what the other already is.

The game involves three kinds of pieces. A first kind disappears on moving across the board and touching another of any kind. A second kind exchanges place with the other. A third kind transforms into the other. The pieces can only move across the board to communicate or touch another neuron. They cannot take intermediate steps. Each player at his turn touches a button that randomly produces paths of motion from one side of the board to the other. These paths remain open for perhaps 5 seconds. The player must decide which pieces to move to the other side of the board given the paths that appear before him. Progressively one player loses more than the other. Progressively one player becomes the other (the others' pieces move to his side) most rapidly.

Having discovered what it means to be intelligent, or, at least, to become intelligent, he grows discouraged, preoccupied by his ability to articulate his message in the sincere experiential way that he knows after so many years as an artist - so long as he cannot identify what has happened with all those other Santiagos he has divided into and who remain for him worrisomely AWOL.

Mathieu hurries down the hall from the kitchen with his athletic long-legged stride. The mad voice pursues him. Mathieu! Mathieu! The identity of the odd sound is too infinitesimal to make out. This naturally increases Mathieu's fear in the way it does in the movies to owners of haunted houses. You are wrong Mathieu! says the voice. There is no way to escape! He enters his study.

Once inside, our harried designer slams the door, whips off his shirt, and quickly stuffs it into the space between the bottom of the door and the floorboards. Turning the old rusted key next to the door handle as a precaution, he races behind his desk and sits down and waits.

He listens. Nothing.

"Mathieu?"

He stirs, elbows firm on the desk. It is the voice of Cécile! She is back from dinner at her mother's. And Andrea? Mathieu listens for the little guy but hears nothing. He can just picture his son sleeping soundly in Cécile's arms, so vulnerable, so unsuspecting of what floats around him.

"Get away Cécile!" Mathieu leaps to his feet.

"What? Where are you?"

"There's a ghost in the apartment!"

"Mathieu, don't be ridiculous. Let me in now." She has walked straight to the study and stands now outside the door.

Mathieu — shirtless in his studio in the dead of winter with his companion banging desperately on the locked door — tries to think it through as reasonably as he can, cold air hitting his back from the iced window. The part about the ghost just came to him. What else could he say? Between a ghost, already ridiculous and terrifying, and a cellular airborne Santiago lays an ocean of absurdity.

Where is Santiago?

Might be heading toward Cécile? Might he be flitting around Andrea's head and ready to get inhaled into tiny nostrils? Or, perhaps he has fallen helplessly to the floor, to be entrained by a puff of air as soon as Mathieu swings open the door.

Mathieu turns his eyes to the ceiling. Paint is peeling off in sheets. He has been working too hard on his design for Le Laboratoire. He has hallucinated. Marching to the door, he grabs his shirt off the floor, and unlocks the door.

"I'm so sorry," is all he says.

"Sorry?" Cécile brushes him aside with her free arm as he struggles to button up his shirt. "Who else do you have in here?"

"Cécile, wait, you don't understand." Mathieu hurries behind her as she moves toward the closet behind his desk. He tries to capture the attention of his son, who has awakened on Cécile's shoulder, while flicking shut the door behind him. A simple smile would do wonders for Mathieu about now. "I've been working late these last weeks, Cécile. You know I have. So I fell asleep here on the floor. And … when you arrived, and called my name, you startled me. I didn't know what I was saying."

"That's a pure lie Mathieu." She looks over sleeping Andrea with impatient slanted eyes, tight accusing lips, in a fit of furor that makes her twice as beautiful as she is. "You want me to believe you fell asleep on the rug, here, no pillow, without a shirt and with the door locked …"

She is very sharp, Mathieu is thinking. "Sounds crazy, I know. But it's true, Cécile. I must have been dreaming about ghosts …"

"Ghosts," she says without much interest, her head inside the closet.

He rubs his fingers through his short black hair. "Right, the ghosts of Le Laboratoire, I guess, the ones Caroline told us about when she joked about why they've moved into the space on rue du Bouloi."

"Right, sure."

Andrea is finally laughing at his father, though Mathieu is now distracted by the sleek gray object sitting on his desk, to the magical flask that is supposed to make plants more intelligent than they are. It is not finished, not yet. When it is, might it save him? Might it save his family?

To have discovered the meaning of intelligence is to have opened up your brain to relentless assault. Endless questions now persecute Santiago day and night: What is Julie doing? Where did Olivier buy his boots? What happened to those other Santiagos?

It is all he can do to toss out answers, like bailing water from a sinking boat one cup at a time. It is insane. Intelligence is insanity, the heart of intelligence a pulsating energy of inquiry, an erotic pulsation – this need for knowledge that eventually manifests itself as a need to find others willing to share it. Intelligence begets love, or at least seeks a certain kind of conversation in humans, if not in ghosts, for evidently inquiry proceeds – and outlasts – matter.

cancer is, as you guessed, not known to travel through the air, though it might were a cancerous cell to migrate into the lungs, into the fluid along the airways, and should the act of breathing rustle the surface, as wind does the surface of a lake, producing droplets like mist on the sea.

He picks up his Nokia cell phone. "Caroline," he says into the receiver.

"Hello Santiago!"

"I need to get it out of my head."

"What, Santiago?"

"David. I need to see him. I propose we get together at 4 rue du Bouloi."

"Sure Santiago. You say when. How about next weekend?"

"No. I can't wait that long. Make it this weekend. We spend two days together and I tell my story. I'll express what it is to become a neuron, what it is to experience intelligence – then it's over. I can't take it any longer, Caroline."

"It's okay Santiago." Caroline chooses her words with precious care. She has never spoken to a neuron. "You want to do this right."

"Don't patronize me."

"I'm not!" She quickly decides on a new tact. "I mean, I'll bring Rémy with me. You know? Our engineer. He'll help you build your niche."

"It's your niche, anyone's niche but mine."

"Whatever."

"Caroline? Are you okay?"

"Yes, oh, it's nothing, Santiago."

"No, what is it? It's like I can read your mind. I'm intelligent you know – or intelligence, a key distinction, I'll tell you. The slightest thought is like an electric shock cutting through me."

"That's pretty odd, Santiago." Caroline holds the receiver away from her body, breathing slowly. "Okay. I have a favor to ask you."

"Go ahead."

"Can I bring Mathieu, too?" Caroline is taking a chance, but she is the art curator, and her fall exhibitions are not going to happen spontaneously. "Saturday lunch, maybe?"

"Sure."

"I think it would be good for him. He has talked about seeing you …" She will not clarify that thought. "It's pretty strange, but I think it's just that he does not really know you. If you saw each other you could talk about what you're both doing, about your experiments – maybe learn from each other, you know."

Santiago laughs for twenty seconds. This is obviously a long laugh for a phone conversation. Then he says abruptly and in a guttural voice, "I'll bring the skeletons."

"What?"

"The drawings. You'll see what they've done with them. Robert and Anderson and Mooney. It's like a portrait of Robert, of what I understand of the brain of Robert, and I really am inside, Caroline."

Something profoundly odd has recently taken residence in Robert's head. Before, Robert always had a thousand ideas. This is still true. But he recognized those ideas and ran after them with abandon. They led him to grounds of invention and made him happy; famous, too. With fame came a familiarity that occasionally leads to boredom. To avoid it he brings his Blackberry along to dreary scientific lectures, spends less time reading scientific articles that fall outside the passion of the moment, and talks to students and colleagues with more pre-selection than he did. Thus he keeps the scourge of boredom at bay by an acquired professorial skill. But this same skill makes him less sensitive to things around him and keeps certain loved people and delightfully arbitrary experiences further away from him than he would like. He does not have as much "fun" as he used to. He is not sure how to analyze it further than this.

But for the last days life for Robert has been splendidly different.

He wakes up in the morning next to Laura and hears the birds singing outside his lovely Newton home. What kind of birds are they? Funny, he does not know, has never learned. How can this be? Birds have been singing outside his window – it is spring – for decades and he never noticed enough to ask.

Now, when birds sing – and he hears them – his thoughts float to Paris. This is new, too. Yes, he loves Paris in the spring. Who doesn't? Before he only thought of this when actually in Paris in the spring. Here, in the Boston suburb called Newton (Isaac Newton? – he never wondered about this connection either), his head comforted by a plush pillow, he can vividly imagine the Seine drifting lazily along, hard to say in which direction, can hear the ring of church bells, smell the wafting odors of fresh bread.

He will occasionally jump out of bed to push this nonsense out of his mind. He has no time for it! Then he will run into his gym, work out on the exercise bike while roaming through his Blackberry messages, take a shower and get dressed. However, by the time he reaches the kitchen he will have an irrepressible urge to drink an expresso.

How odd! He never drinks expresso! Well, he does now. He also eats croissants.

"Would you like to take a walk?" he said to Laura the other day. He had come home early from MIT, which he never did before. He found her

intelligence and insanity are more biologically connected than we might care to believe, as seen in the recent scientific study, where scientists at the national institute of mental health in the united states demonstrated that most people seem to inherit a gene that simultaneously optimizes cognition and the chance of severe mental illness.

reading a book in the living room.

"Walk?" She stared at him over the edge of the book as if he she hadn't heard properly.

"You know, flâneurs."

"I didn't even know you knew that word." She put the book down on the glass table next to the couch.

Robert chuckled. "Oh, let's do it, ey?"

They walked around the block and laughed (he laughed) that afternoon.

At one point he waved at his neighbor Bill. "Hey there, Bill! Looking forward to being out here soon with you, mowing the lawn!"

"Mowing the lawn?" Laura asked under her breath, as if to avoid public embarrassment. "What are you talking about?" Robert meanwhile kept his eyes on Bill. "You never mow the lawn!"

Robert chuckled again. "Relax, Laura." He put his hand around her back as they started to stroll again on the suburban street – no sidewalks. "It's spring."

This is all odd, of course. He sees it as odd, but cannot resist it. He feels like a piece of debris floating on the Seine, twirling around in little pleasantly inevitable circles.

At work he puts his feet up on his desk. He never did that before. "Andersen," he will say. "How is your wife? I'd like to see her more than I do. Bring her to lunch sometime. I'll get Laura. We'll go downtown, take a break. Good for the mind, you know."

The old ideas still run around in his brain. He has not forgotten about all the companies he has created, the new technologies that are emerging out of his lab, the talks he has agreed to around the world. Thankfully, he remains responsible.

Barely.

In faculty meetings he stays longer than he did, doodling.

He answers less frequently his Blackberry messages. "You take care of them, Nancy," he tells one of his assistants. Whether she answers or he does is not essential, he believes.

He plays ball with his son Sammy. "What's wrong with you, dad? You got a problem? Something not going right at work?"

"Intelligence, Sammy – it isn't what you imagined it is. I feel as if I am learning about it all over again."

"Whatever," says Sammy. Sammy is eleven. "Kick the ball."

"What does he look like?" Aurélie calls out from the kitchen, where she

prepares dinner for David and Daniel and Santiago. Her cheerful voice speaks of reconciliation. Okay, finally, she will live in a lab: she, her kids and husband – objects of creative enquiry. It is not so new to her. In her first sixteen years she lived in ten different countries. Was not that an experiment? Well, this is not quite the same thing. Santiago has become a neuron, David says. He will have something to say about intelligence. Aurélie is going to learn over dinner, he says. Yes, yes, maybe so, though maybe not – and in the incertitude is the fun of experimentation. One never knows it all. If you did, what would be the point in the experiment? In her youth, she faced a new surprise every two years. But it was a controlled surprise. Her father remained a banker and her mother a teacher in whatever French school she attended – in whatever country she lived. Younger siblings followed her around. So there were fixed parameters in the laboratory of her youth. It was nevertheless what changed that made her ever sensitive to what she did not know, curious to know more, and in a certain way, human. She puts a pan under the faucet. Dinner preparations loosen her brain at the end of a hectic week – ally to intelligence, she muses.

"Santiago?" David stands at the window staring at Carrefour de l'Odéon. If Aurélie has evolved this past year, so has he. He has stopped wondering why he turned his back on a successful academic career. Months before it opens, the lab has become his context. He created this (what?) to create with others who in their creations experimented with their own lives as he did and who did not question the rightness of it. Such is the underlying hypothesis Santiago and Mathieu and Robert have confirmed through their experiments even before arriving at their results. Of course, he cares – they care! – about results. But results will validate nothing that matters to him. He watches red car lights stagnating up the boulevard in the direction of Saint-Michel, a young crowd mulling around the Odéon Metro Station beneath his window.

"He's a neuron now – or a cancer cell – depending who you speak to," he says to the window. David is untroubled by the ambiguity; change introduces ambiguity into the minds of those who are not capable of it. Down below, Daniel and Santiago hurry across the intersection in front of the café Danton. He turns from the window, saying, "I hope it will be what he wants."

Aurélie has slipped back into the living room. She is sitting with a New Yorker magazine on her knees, feet up on the coffee table.

"The dinner?"

"Santiago, the experiment."

the will to **innovate**, and even more to remain innovative, makes us resemble our magical stem cells, which manage to avoid exhaustion, time and again creating, by remaining near their niche. this search for a sustained creative life is our search for a niche.

"I've never talked to a neuron, let alone fed one. It's the dinner I'm worried about."

"I'm thinking about this weekend, tomorrow, then Sunday."

The door buzzer rings.

"Boys!" Aurélie yells at Jérôme Raphaël Thierry — playing Luke Skywalker in the playroom. "Settle down. You'll be going to bed in a minute!" Her words have no audible effect on the progressive rise of playroom noise that accompanies the mutual arrival of bedtime and the unknown guests who might extend it.

David presses the button.

"Fourth floor," he says into the door phone.

"Will you see Mathieu this weekend?" Aurélie asks casually while passing behind him on her way to the kitchen.

"Yes, he should be there. He wants to see Santiago, you know. He keeps talking of the problem ..."

"Sounds like _he_ has the problem," Aurélie yells while critically sampling the odors wafting from the open oven door. "Do you really think it could be true? All those other Santiagos?"

David enters the kitchen. "I think it may just be Mathieu overly worried about his filter working. Once it is successful, I suspect everything will be okay."

"But let's say it's true." Aurélie heads back to the door to receive her guests. "If a cell could actually speak, and track down people like people track down cells, would that cell, in your hypothetical case where Santiago turns into a neuron, identify itself as Santiago, and, if so (all of which makes me deeply skeptical, David), what would this mean about intelligence?"

"Well..."

"It's one thing for the path to intelligence to be full of wrong turns. We know it is. But your case would mean that to become intelligent would not mean simply to err many times and have survived the errors, but to live your errors as parallel infernos. It would be intolerable, David. I don't think I could stand it."

"I see your point." David touches her cheek. Even to David it is remarkable how ambivalent he has become about answers. "Cells or people, we all leave identities behind."

"Genetically speaking ..." Aurélie goes on, waving a hand before the elevator door.

"Let's drop it, Aurélie." David claps his hands. "Guests are here." His boys scurry to their feet. "You guys going to sleep tonight?" They

flood past him to the door.

"No!" they yell in perfect unison, darting around his legs.

"Good. Now, you're all going to say hello. Shake their hands. No throwing yourselves on top of them. Try to be French, okay? Reserved, polite, normal. Got it?"

Having dazzled his hosts at dinner with his prodigious ability to answer – or ask – questions in the precise instant Daniel Aurélie David sensed them as meaningful, Santiago has fallen, deeply, suddenly, maddeningly and gravely ill. This is the message Caroline shared a second ago over David's cell phone while he walked with his boys to school through the Luxembourg Garden. He is just now passing by the tennis courts.

Caroline is saying. "Didn't you check your email?" Her voice is low, tense, nervous. "He can't make it. Think of all we planned this weekend for rue du Bouloi and now he can't come …"

"I hope it isn't something he ate," is all David can think to say as his four-year old wanders behind to examine a dried chestnut. "We had him over last night with Daniel. He looked okay. Very neuronal." David puts the phone down around his stomach. "Come on Thierry!" He stops his two other boys to allow the little one to catch up with his back pack flopping up and down. "Really sorry, Caroline, okay, so we'll meet later." He nears the edge of the park at rue Guynemer. "It'll be okay. Mathieu is coming anyway. We need to see him, you know. His design might be ready. See you at 11:00 at rue du Bouloi?"

David leaves his boys outside their 6th arrondissement school – quick anxious kisses touching his cheek as kids and parents storm by to meet the eight thirty deadline beneath the watchful eye of the director. Twenty minutes later he swings by his place at rue de l'Abbaye for a quick exchange of emails with Robert.

Subject: Change of plans
From: david@laboratoire.org
Date: 3/31/07 9h27
To: Robert@mit.edu

Hi. Santiago is sick. May call you Sunday.

Subject: Re: Change of plans
From: Robert@mit.edu

Date: 3/31/07 9h57
To: david@laboratoire.org

Really sorry. I'm not feeling super myself. Good luck. Cold and wet here. No birds this morning.

It does not occur to David to ponder the oddness of Robert's note, the coincidence of illnesses, the curious comment about the birds.

Progress at rue du Bouloi has steadily advanced since receipt of the early January building permit. During the week the street hums with jack hammers. Floors fall, rubble floats away on the shoulders of strong compact Portuguese workmen, pipes arrive on the backs of flatbed trucks. Each week François admires it all with hands clasped behind his back like Napoléon at Austerlitz. Dominique, the French architect (Peter, the Canadian architect, shows up only occasionally), worries over details, project delays and cost overruns, while Christian diligently lays out the electrical systems, and Rémy calls on his most trusted contractors. On the weekends things settle down to a hushed calm reminiscent of the old ruin ...

Such is it today, Saturday, when David and Caroline enter 4 rue du Bouloi before the others arrive. They walk for several minutes around the worksite saying nothing, each listening to whispers of the ghosts.

"Do you hear that?" David asks.

Caroline nods that she does.

"They haven't left."

"They didn't speak before. What's going on?"

David shrugs, looking left and right, as he climbs over mangled iron girders to makeshift wooden steps that lead to where Daniel now stands.

"Good morning David."

"Morning Daniel."

"Nice dinner."

"He's sick. What's happening, Daniel? Did you see him?"

"Yes, I saw him. Very ill. And sorry not to be here." Daniel wears the requisite long face as they each remain silent for a few seconds. Then he changes the subject, tone brightening: "What's this?" He stands before one of the paintings that Julie drove over to 4 rue du Bouloi for this weekend of the niche, camera lens a few centimeters from the canvas.

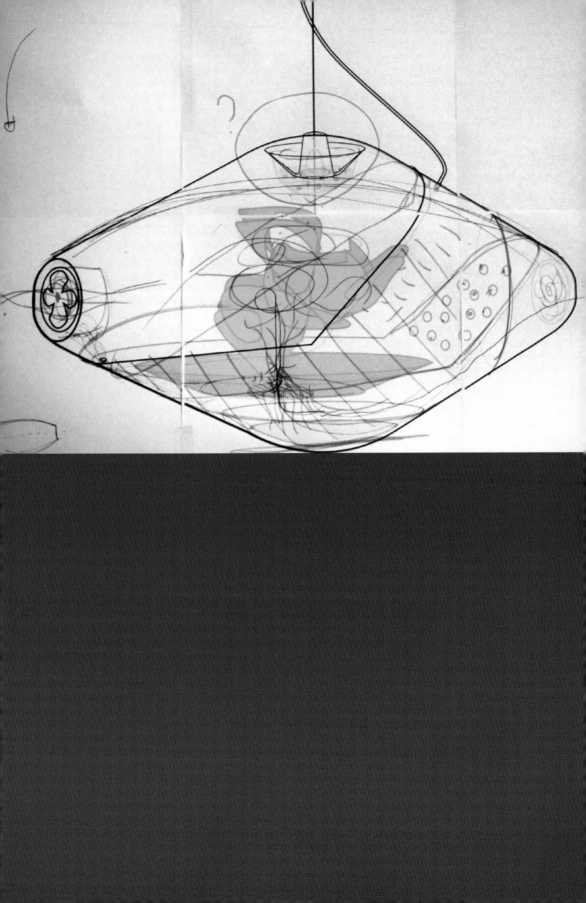

"Bubbles," says David, walking over. He says, "Look." He points a finger. "To be a cell is to be a bubble of champagne. Here." He shows the trail of circles. David is trying too hard. What else can he do without the Artist Neuron? "The way they rise and divide, multiply and transform. Bubbles are like cells, he may be saying. There is the euphoria of them." Privately, David thinks also of the inherent instability, but decides it best to avoid the issue. Bubbles are beautiful because they are fleeting. "Look at the bottle – the bottle filled with apples." He wants to distract Daniel's attention and his own. There is artificial cheer in his voice. Something is wrong, he realizes, ghostly whispers whirling around him. "The apples are also cells, and the apples fall to the ground to become ..."

Daniel throws a quizzical look at David. His scorn is amplified by his considerable height. "You're not telling me what I'm seeing, David. You're interpreting. You want me to believe this is what he's thinking."

David waves a hand. He has not mentioned to Daniel the ghosts but cannot stop thinking of them now. "I might be wrong."

"And this?" Daniel approaches a second canvas near to where Rémy stands on a ladder carefully analyzing a future video projection surface.

"When is Mathieu arriving?" Caroline is asking Rémy, oblivious of Daniel's approach.

"Here is Robert," David explains, still at Daniel's heels. "There, that photo, or this one – try to capture these if you can."

"I don't tell stories," Daniel replies in a firm voice, neck arched.

David would like to say that he does not believe in stories. Daniel was not invited to tell one in any case. But, then, creating is nothing if not a story.

While one experiment remains in limbo, another rushes to its conclusion. Mathieu, the designer experimentalist, slips onto a bench at the Café de l'Epoque, and calmly listens to small talk about light fixtures, budgets and opening day permits. He glances around, eye out for Santiago, his hand touching an edge of his rucksack on the floor next to his chair.

Caroline wonders if he has something to show, her hand gently touching Mathieu's wrist.

"Sure, right here." Mathieu nods casually at his rucksack. In the contract he signed with Le Laboratoire there were a couple dates – one is today: the Preliminary Drawing Date. He gets paid. Not for a solution but for a path to the solution that they will all wish to discuss and debate.

"Get it out! Get it out!" shouts David, leaning forward over the table, as a sign that Caroline, Rémy, Daniel and a few others should do the same (they do), everyone half smiling in the way you do when kids open presents on Christmas Day.

Mathieu pulls a stack of drawings out of his rucksack and places it on the table.

David immediately fans them out over the uncluttered center of the tabletop. "I love it." His judgment required all of thirteen seconds. David used to wonder about his impulsiveness until after many difficult years of misunderstanding he came to see it as a primary resource, a thing to preserve when age and accumulated experience argue you should not. "Does it work?"

"I think it does."

"So you've created intelligence."

"It's pretty heavy, is the only thing," Mathieu says with coy misdirection. He pulls from his coat pocket a cigarette pack with a white label: Smoking Kills, adding, "Had to make it out of metal. Plastics poison you. Be pretty dumb to increase the intelligence of plants by a device that turned around and lowered its value."

"Good point Mathieu. Too bad Santiago isn't here. He's pretty near to the end of his experiment, too. But I suppose you've heard that by now." David lifts up one of Mathieu's images. "The air – maybe you can move the source closer to the plant, get the air moving inside the leaves, have the leaves battling evil for you."

Mathieu laughs unconvincingly. All at once he puts the cigarette pack down and pulls a pen out of his pocket. Pulling the page out of David's hand, unlit cigarette hanging between his lips, he quickly redraws the fan next to the plant. He knows exactly what it should look like, as if David's question happened to foreshadow what would next spring from his fingers. "Would that work?"

"Yeah, that's it." David eats a sliced tomato from the ham and cheese salad they named after the Vero Dodat gallery just over Mathieu's shoulders. His ideas move on: "And the water?" He points his fork toward the base of the design. "You really need two sources?" He moves the fork to the top of the design where a splotch of blue appears.

"I'm concerned about the leaves," explains Mathieu. "They dried out last time we did an experiment." He lights his cigarette, eyes narrowing.

"Here's a thought," interjects David. "Put the water underneath the plant in virtual contact with the soil. That will maybe do it."

"The roots will grow into it. I know they will. It happened to us

once."

"Neat. Good, do that, then. The plant will get all the water it needs. And, then, like we said before, the air that comes from the soil will touch the moisture and stay clean that way."

"You sure you want to suspend this?" Rémy sits at the other end of the table eating his steak tartar.

"You could place it on a surface, if you wanted." Mathieu finishes his cigarette while glancing distractedly into the gray street. "Just makes more sense in the air, I think." Suddenly he crosses his arms. "Hey, where is Santiago?"

"Sick," adds Daniel, nodding a few times as if confirming something already said. "Pretty bad state when I left him this morning." He goes on nodding.

"That's not good," says Mathieu.

"Why do you say that?" Caroline wonders.

Mathieu lights a new cigarette and retreats into a private realm of his mind. Since the night Cécile came home and found Mathieu cowering without a shirt in his office, he has worked unceasingly. Personalizing airborne debris does this to you. Breathing becomes an effort, a conscious reply to the will to live, something you would avoid if you could, to keep your lungs clean. Fortunately this personalization of his enemy only explicitly lasted one evening. But the memory of it galvanized him into action. How important the intelligence of a plant seems to Mathieu now that the dust that threatens to poison him has assumed a voice! If only Mathieu could make plants still more intelligent, would not Cécile and Andrea and Mathieu be happier?

Experimentalists tend to dramatize the importance of their work in proportion to their obsession that it reaches a happy end.

After shooting off his email to David, Robert walks out to his car and begins the lonely drive to MIT. In the space of the past three weeks, he has imagined, all by himself, a new way of delivering genes via artificial viruses to healthy stem cells and, with Anderson, a method to screen for the right materials on which to grow stem cells, and, with a really bright student in his lab, a way of healing spinal cord injury, again with stem cells. Probably not in his entire career has Robert had such a fruitful research riff as he has had these past weeks.

What is happening?

They have only spoken a few times since their January meeting —

now it is early April — and, yet, each time they do speak Robert feels a powerful alliance with Santiago. He will talk to Laura about it whenever he has the chance.

"And then there was this chocolate sundae!" he will say.

"Enough already," Laura will sigh. "You made one lousy sundae at David's and called it a stem cell. Big deal."

"It was very good."

"Are you going to go to work now?" Laura will reply with exasperation. "Why are you always hanging around the house anymore? I can't get anything done …"

"I have ideas wherever I am. I don't need to leave you now."

"You always had ideas. I didn't complain. Why would I? I didn't have to listen to every single idea, didn't have to listen to you transitioning from lawn mowers to macrophages, from sundaes to spinal cord injuries. Only the tested, finished ideas made it home. But this? I can't take much more."

Well, he is thinking morosely, as he drives down the unpleasant end of Commonwealth Avenue, about where David got so lost back in January, maybe she won't need to. Somehow reading David's message this morning — the note about Santiago falling ill — did something to Robert. He has no other word for it than blasé. He feels blasé. It is the state you have in the morning when you awaken from a fabulous dream that you realize immediately will never be true.

After lunch at Café de l'Epoque Mathieu goes over to 4 rue du Bouloi and walks down the steps into the cavernous dusty interior. Almost instantly he knows what he has to do. He does not reveal to anyone his resolution. It is not an idea he will need to test first on others.

As he discusses with Caroline the hanging of his exhibition Mathieu privately listens to the voices. At one point Caroline, amused look in her eyes, notes that the ghosts have returned. Mathieu smiles at these words. The voices he hears — cackling, taunting, vicious influences — could not belong to the remnants of real lives. They are not testimonies to what has been, just the opposite. What Mathieu hears — obviously he knows what to listen for — are the voices of lives not lived, commitments not made, left to roam the world without soul, alternatives not taken.

When he first visited rue du Bouloi, many months ago now, Mathieu felt the presence of specters. He did not hear them. They swept past him without pause as if to remind him they belonged to a world that

was not his lest he made the effort. They caused him to wonder at the events and people and ideas that had graced this earth and commanded through the level of that grace a geographical urban sanctified corner for experimentation.

The feeling today is completely different. It is the feeling he had in his apartment that day he feared failure.

The next day, Sunday, Mathieu drives Cécile and Andrea south of Paris to the forest of Fontainebleau. They hike here for three hours through the cold dark woods, breathing the fresh air, Andrea strapped to Mathieu's back. It is during lunch in a matted meadow that Mathieu finds his hale spider plant. Pulling from his jacket a spade, he digs it up and presents it proudly to Cécile.

"I have it," he says. "We can go home now."

"That's it? It's not so pretty, Mathieu. You sure you want to carry it back?"

"It's not beauty I'm after, Cécile. Let's go."

On the way home Mathieu explains to Cécile that she will next need to take Andrea to a cousin's home in Brittany. He will call her when she can return.

"Last favor," she replies, lips pressing tight.

"I'll call you in three days. Then it will be over. Promise, Cécile." Mathieu smiles confidently with his sure hands on the plastic steering wheel. "We're almost there!"

Cécile looks around uncomprehendingly at the gray façades surrounding the Porte d'Orléans.

On Monday morning Mathieu gets up at five o'clock and heads straight to his studio with his spider plant. His staff of three arrives by nine. They work through the day without breaking for lunch. That night he sleeps five hours and the next day he heads back to his studio three hours before his team. The goal this new day is to finish the prototypical filter his team has put together for the sake of the spider plant with materials purchased at the local Monoprix.

All this brings us to Tuesday night when Mathieu calls David at his home.

"Mathieu?" David puts his *Le Monde* on the floor, gets up off the couch. "It's late. What's going on? You okay?"

"Do you have the key to 4 rue du Bouloi?"

"Yes, yes of course. Why? What is it?"

"The experiment, David."

"What experiment?"

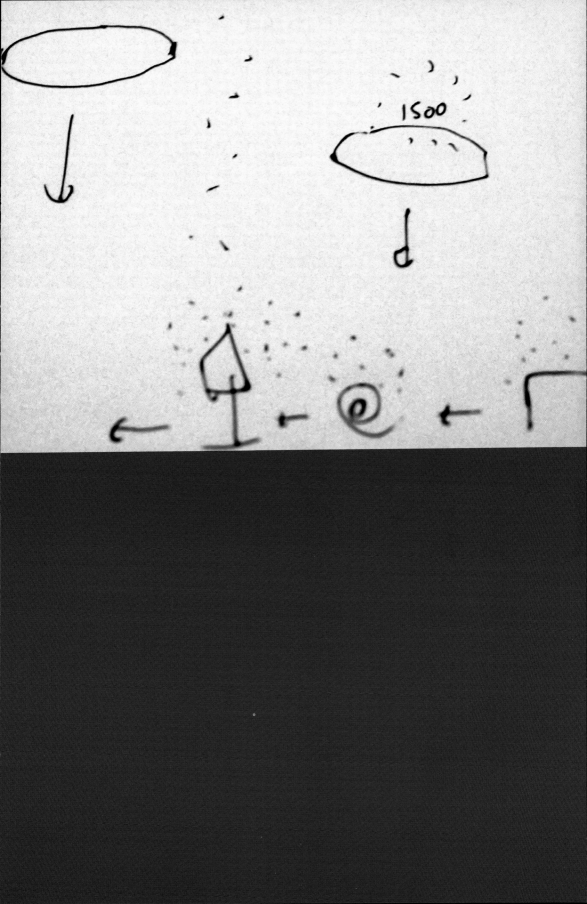

"The experiments we're all doing. The reason you've moved to Paris. The *experiment*: you and me, scientist and designer. Surprise. We're doing an experiment together. And tonight is our most important night. You have to let me into Le Laboratoire. In an hour. Can you make it?"

David studies Aurélie, reclining on the couch, her attention loosely absorbed in a Jonathan Franzen novel. "Okay. Ten." He shrugs Aurélie's way. "I'll meet you in front of the door."

Half an hour later Mathieu and David stand with their backs to the mighty Banque de France, nobody in the entire square, each peering down into the dark basin of 4 rue du Bouloi, like partners on the eve of a heist.

"Let me go find the power switch," David says.

"Be careful," whispers Mathieu, perspiration already running down his face.

"Hey, take it easy," says David. "The ghosts are harmless." He laughs.

"Just turn the lights on, okay?"

David goes down the steps and flicks on the power switch. Mathieu immediately clamors down the lit steps with his prototype under an arm. Inside the plastic housing is the spider plant, and beneath the plant a couple liters of sloshing water. An electrical cord drags behind Mathieu over the stairs.

He sets his precious object down at the base of the stairs and hurries to plug in the cord. The motor begins to hum. Mathieu next sits down on the last step of the stairs, back to the open door and night air, and pulls out his cigarette box.

"Oh, please," says David, sitting down next to Mathieu on the steps. "You're trying to filter the air, not dirty it."

"There's already tons of dust in this place, David." Mathieu lights his cigarette.

"Good point. So what are we doing here? An experiment needs a test, Mathieu. How will you test whether this thing works or not? You need some measure."

"Intelligence, David." Mathieu nods knowingly with the cigarette glowing in his mouth. "Rue du Bouloi is going to become smart again."

"So I must be getting dumber."

Mathieu rocks with laughter. He has not laughed so sincerely in three months. "The way I've defined intelligence it doesn't matter anyway."

"Great — intelligence not limited by human understanding.

Humanity has hope."

By the start of the week Santiago has emerged from his mysterious health crisis. Fighting lethargy – it is Monday, he believes – he rolls out of bed, slips on some old high school jeans, and climbs down the wooden stairs to his atelier. The sun shines in the courtyard. He walks straight to it and opens the door and stands here enjoying the warmth. It is not the warmth of the blanket that has covered him these last several days, nor is it the warmth of the water bottle he had over his forehead. It is natural biological heat, the heat of chemicals reacting exothermically and faster than you can count. Fireplaces give you this kind of heat after a day of skiing. Nutrients give it to stem cells in their niche. And it is what Santiago feels more purely than ever before.

What has happened?

For a week he has been unable to get out of bed, unable to think straight – and, this, after a month where every thought had a purpose, every second a thought. It might have been something he ate, a bad vegetable over lunch after the dinner at David and Aurélie's. It might have been one of those annual crises of nerves that hit him at his most productive moments. Whatever the origin, the Malaise is gone. The disequilibrium, the nausea, the sense of total distraction – all the evil of the past week filtered out of him.

Turning back to his atelier he approaches his drawings, all lined up perfectly against a wall, like preparatory students enduring the annual review of the director. He moves from the first to the last, remembering through the images what he has experienced. Possibly the entire aesthetic reality of stem cell transformation appears on these canvases. Even were this not so, who could tell the difference? Only Santiago has actually become a stem cell. And he will vouch for the fact that not every stem cell becomes a neuron, and only the rare breed a neuron in Robert's brain. This was his experience. And it is before him, aesthetically speaking.

When he drew these images – the bath, the net, the hourglass, the food, the sculpture, the bubbles and apples and the brutal game of nerves – he did not perceive of them as forming a composition. Santiago drew these images as if were he not to draw he would not be – would not remain – Santiago. This may sound silly to the reader; perhaps it is easier to see that Mathieu, the designer in search of a certain property to realize a certain useful end, did not view his spider plant most particularly as one element in the great natural coexisting fabric of the forest of Fontainebleau.

Santiago has decades of experimental creation behind him. And yet each true experiment carries him back to the edge of who he is. He can fear failure, not in the sense of a Mathieu, who might be wrong, but as the artist whose mind can splinter, stray, and divide too easily into a thousand ideas running wild.

A surprising idea comes to him. He has not only become a neuron in Robert's brain — he has managed to explain what it means. What? "Explain." He says the word out loud. There. He will not say it again. For the scientist to explain is to open a field of exploration while for the artist "to explain" is the formal burial of what once lived.

Rémy, please!

Enter the engineers.

Santiago loves to work with engineers. He likes industry. Those who create are more easily understood by Santiago than those who explain.

Together they will make objects and paintings — many paintings — and sculptures and there will be a meal to prepare too.

Robert, I know you!

Intelligence!

Robert feels blindsided. It is about how he felt the day he learned that a first paper of his would be published in the Journal Science — a report of his research on shark skin and cancer. Till that point in his life ("the shark skin inflection point," is how he sometimes thinks of it), Robert had lived in laboratories, working late nights, pouring concoctions into test tubes, arguing over ideas, ever skimming through scientific journals. He created and created and ... that is all he did. Then his first publication appeared in the Journal Science. How fine that was! For a few days it was fine. The shark skin story — the notion that the skin of sharks might possess a secret to curing cancer — was out. There followed interviews with newspaper journalists, invited presentations at international conferences, even a special investigative report by the US news show 60 Minutes! After those few days all the hoopla proved to be a let down, really. What had kept Robert in the lab, studying, dreaming, revising his dreams — was the thrill of creating, not the eye blink of the creative result itself. He had not even been able to guess what that creation would be! Interesting, curious, fun in a way — the result of his creation left him a bit sour. This is precisely how he feels now.

A cold blistery snap of weather has ruined what seemed to be a

memorable Boston spring. Added to this, the remarkable productivity of the last months is behind him. How does he know? For one thing, he dreams no more of Paris. He also has much less time for Laura and his kids. He travels a lot to New York and Washington, occasionally to the West Coast and overseas. The croissants are over, the hard black coffee, too.

Robert has returned to who he was – brilliant scientist without Santiago.

What happened?

He will figure it out when he travels this fall to Paris for the opening of Le Laboratoire. What will he then see? Actually, he does not spend five seconds reflecting alone on that question. Occasionally, perhaps over dinner with Laura, or with close friends (nobody like Santiago, no deeply allied and essentially disinterested creator), he will muse a little, a glass of wine dwelling a little longer in his fingers than is normal for him. A wistful look will fill his brown eyes, which may water slightly. Fond memories will carry his spirit away, however fleetingly.

In these moments Robert imagines his future trip to Le Laboratoire like one of those returns to the Upper New York State neighborhood of his youth, where, amid the familiar sights and reminders of old and nearly forgotten experiences, there is ever the chance of running into a former love.

Our mystery leads us, inevitably enough, back to 4 rue du Bouloi.

There is, after all, a harmony at number 4, a harmony occasionally broken over the last several hundred years, as we previously alluded. There was, for instance, that venerable – and eventually loathed – institution we called the Farmers General, which held its meetings at rue du Bouloi from late in the 17th century through most of the 18th. Halfway through its lifetime at rue du Bouloi things began to go bad for the Farmers General.

Who did not know? The powerful taxation body robbed from the poor to give to the already fat and rich! Who, other than the few who benefited from it, wanted it to remain? You would think this reviled institution would have at least listened, and, recognizing the threat if nothing else, would have changed its policies to survive and flourish in a new way. You might think it would have found some way to distribute a fairer percentage of its riches to those who needed them, the very ones who, as it happened, guillotined many of its members by the time the

French Revolution came around. Well, these things did not happen. They remained alternatives not taken. The Farmers General eventually did not belong on rue du Bouloi. The institution disappeared.

For years our street remained a deserted place. Ghosts appeared, or so we believe.

Then a printing press arrived, one of the first and largest presses in France. Suddenly things looked bright again on rue du Bouloi. The ghosts made way for this fine new tenant, who, in a certain true way, mightily controlled communication in all of France! Because of Dupont & Compagnie a citizen in Marseilles could read about the latest literary success of Emile Zola, while a citizen of Lille could learn about the latest textile invention. This went on for several decades.

Then, as you have guessed, art and science advanced. This mattered to Dupont & Compagnie since fine printing is nothing if not a mixture of art and science. Our printer might have advanced, too. Could he not have? The company might have invested in the new technology that transformed communication in the 20th century and remained at the forefront of the communication wave, but, alas, it did not. Such opportunities remained alternatives not taken. Prices fell, business lagged, and, eventually, the printer needed to close its doors.

Rue du Bouloi turned silent and spooky again until a television studio came along.

Television! Here was the future of communication! The company Télé Europe remained on our street for a while, shooting interviews and commercials and an occasional news program.

But, no, it did not last long either. Why? Technology advanced, communication media diversified, and, predictably, Télé Europe did not. It left our venerable street, downsizing to a less central and demanding spot in the city.

What is going on?

At rue du Bouloi there is a ghostly consensus that an idea conceived should be developed, carried forward, and transformed by the testing, evolving into whatever form it assumes through intelligent adaptation. This, at last, is the story our specters would tell if they could speak – and what led to the flight of the venerable ghosts of rue du Bouloi following the sudden invasion of all the non-neuronal Santiagos.

The non-neuronal Santiagos came, as you might have gathered, to beat Santiago the Neuron to the opening show. Naturally, their unwelcome arrival drove our ghosts away, for they (the ghosts) could not stand the presence of these alternatives not taken any more than they

WATER INPUT

AIR INPUT

SOIL AND PEA GRAVEL

AIR EXTRACTION

could stand the presence of the Farmers General, near the end, of Dupont, in the bad years, or of the film studio, when its fortunes flagged. They left. Fortunately, the cellular invaders were eventually filtered from the air through the intelligent device of Mathieu, which, rather than growing dirty, as any other filter might have – rather than providing a home in which all these non-Santiagos might have nested and grown, only to be re-entrained so as to poison the street longer than they did - absorbed the noxious cells, broke them down progressively, and consumed their parts, drinking their water, eating their fats.

This gave Santiago, when he was the neuron, back his sense of a unified experience (and Robert, too), which is after all what he (and Robert) aimed to achieve at Le Laboratoire, and, so, he (and Robert) subsequently gave to the world a stunning exhibition, the reality of which our curious story affirms. Having gifted the world in this way we (the world) reclaimed Santiago the Artist.

Robert, meanwhile, lost the coexistence he experienced with Santiago when the latter resided neuron-like in his brain, and, thereby abandoned, however temporarily, the dreamy experience that so reminded him of his younger years, even as he took some satisfaction in the memory and in the knowledge that his experience acquired at last a public form.

Quite a yarn, our story, though perhaps we were born for it; at least our names possess a very tight connection to it. For Plessis – as in Armand, as in Cardinal Richelieu – entered the world here, as we have earlier said; and Séguier – as in Pierre, the Chancellor, the Keeper of Seals – bought the entire street in 1634. (And by the way, I, Séguier, did purchase some of the street, later on; whereas I, Séguier's co-author Plessis, do pontificate when I can.) Plessis, as you know, founded the Académie française. He became its first Protector. Then he died and Séguier, a younger man, became the Protector of the Académie. So the first two Protectors bore our names, just to be clear.

In those days, when Séguier took over, the Académie française met on rue du Bouloi, in Séguier's home and surrounded by the richest library in France aside from whatever it was that belonged to the King, who, logically enough, assumed the job of Académie Protector subsequent to the passing of esteemed (if sometimes vicious, not always a happy man) Séguier.

In those days, when rue du Bouloi began to exist on the international

...FRA

...és par mois)
...ïl
...nte (5 ans avant maturité)

(X)

→ chaud, sec, norma
lumineux.
→ eau 1×/semain
la terre entre c
→ engrais 1@/r
→ très proche (n.
Mother-in-l
ou snake plant
→ sommet sec

(X)

trouvé courau
bois aggloméré, pa
mouchoirs, PQ...
ménagers, tissus
colles pr sols...

scene, the Académie, which held it séances here, was undivided. What we mean by this is that there were not all the other disciplines that muddied waters later on. There was only one. The notion of art and science remained unified. Ideas, we can assume (we do assume), had a kind of wholeness. Then, alas, the academy moved on, drifting away from rue du Bouloi.

An alternative not taken!

As soon as it moved on, all the *other* academies appeared. First we added an academy to painting and sculpture, then of science, and eventually there came the others. We created the French Institute to encompass them all. Academy members did not mix freely. They met in separate sessions, talked about more narrowly defined subjects, and did not invade the territory of the other academies. In short, the world became what we know it to be today.

Meanwhile, the original spirit of rue du Bouloi continued in the form of our ghosts. They did depart occasionally — for instance, when the Farmers General ran its good luck into the ground, and so forth. Now, we are happy to announce, they are back. Le Laboratoire welcomes them as part of its mission. And this is testified to by the story of our hero the stem cell who became a neuron - and were it not for an exceptionally smart spider plant brought all the way from the Forest of Fontainebleau might have become many other things he did not intend.

★ ★ ★